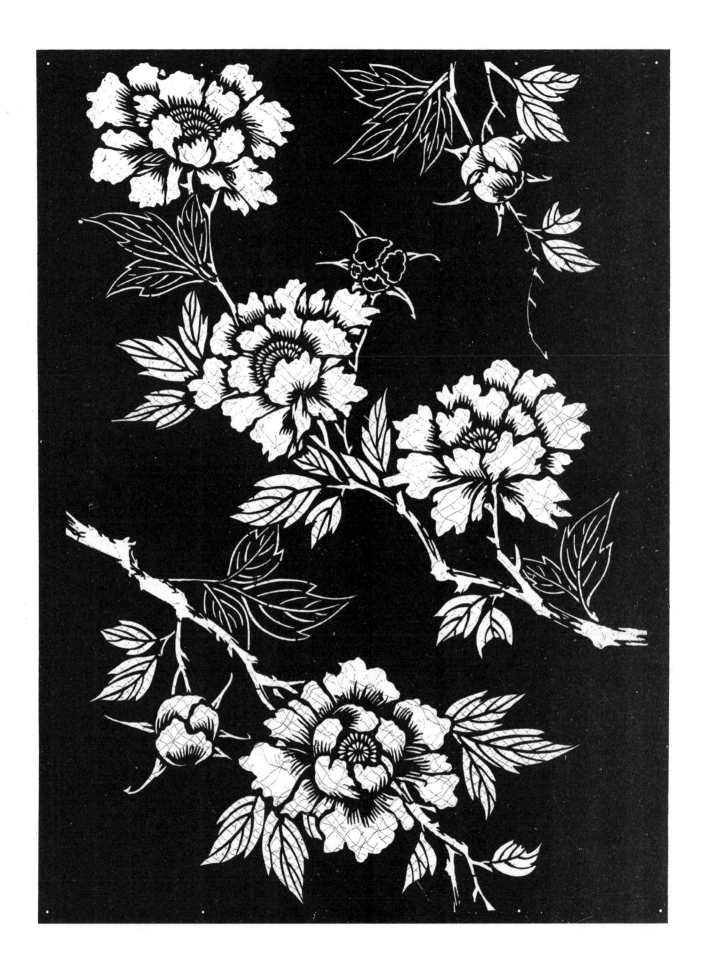

100 Japanese Stencil Designs

Edited by
Friedrich Deneken

Dover Publications, Inc.
Mineola, New York

Note

For centuries, Japanese artists have been renowned for the subtlety, ingenuity and acute artistic sensibility of their designs. They have evolved these qualities in the course of a long-lived artistic tradition that often focuses on plants, birds, flowers, fish, grasses and other natural elements. With seemingly effortless skill, the artist recaptures their beauty and delicacy, and presents them in dense, intricately balanced patterns. This mastery is wonderfully evident in this collection of 100 stencil designs, reprinted from a rare 19th-century German portfolio. Depicted here in styles ranging from realistic to deeply stylized, are such familiar Japanese motifs as peonies, bamboo rods, pine branches, dragons, carnations, chrysanthemums, cranes, carp, lilies, and other plants and animals in a profusion of eye-catching tableaux. Artists, craftspeople and any lover of Japanese art will treasure this abundant supply of authentic, ready-to-use stencil designs.

Bibliographical Note

This Dover edition, first published in 2006, is an original selection of plates, slightly reduced in size, from *Japanische Motive Für Flächenverzierung: Ein Formenschatz Für Das Kunstgewerbe,* published by Verlag von Julius Becker: Berlin, 1897. Plates 3, 14, 18, 83, 92, 94, and 98 of the original have been omitted from this edition, along with the foreword and introduction. A Note and new English translations of the original German captions have been specially prepared for this volume.

DOVER *Pictorial Archive* SERIES

This book belongs to the Dover Pictorial Archive Series. You may use the designs and illustrations for graphics and crafts applications, free and without special permission, provided that you include no more than four in the same publication or project. (For permission for additional use, please write to Permissions Department, Dover Publications, Inc., 31 East 2nd Street, Mineola, N.Y. 11501.)

However, republication or reproduction of any illustration by any other graphic service, whether it be in a book or in any other design resource, is strictly prohibited.

International Standard Book Number: 0-486-44724-3

Manufactured in the United States of America
Dover Publications, Inc., 31 East 2nd Street, Mineola, N.Y. 11501

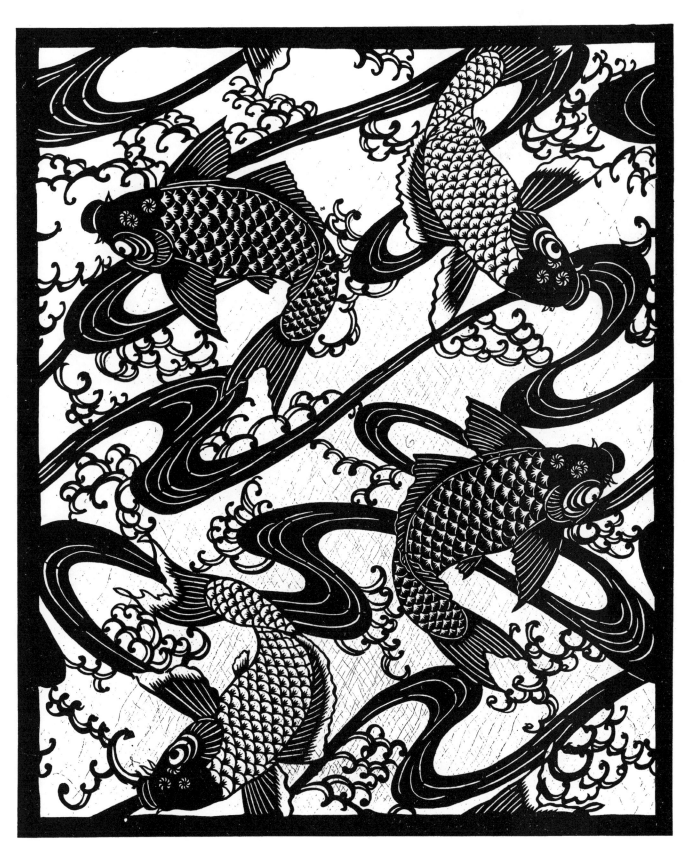

1. **Carp Swimming in Waves**

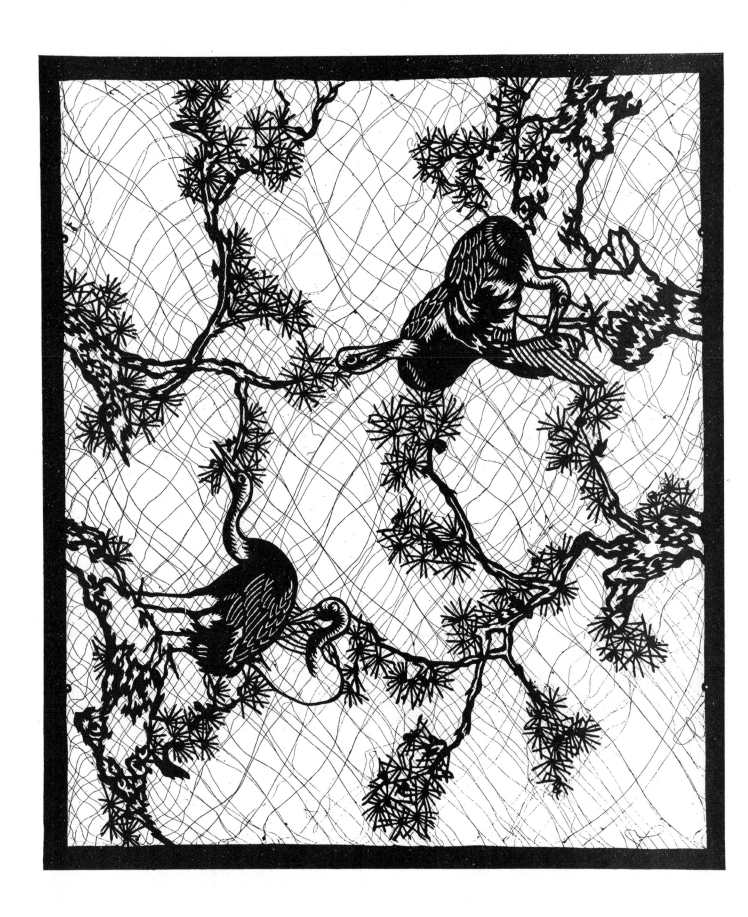

2. A Pair of Cranes in Pine Branches

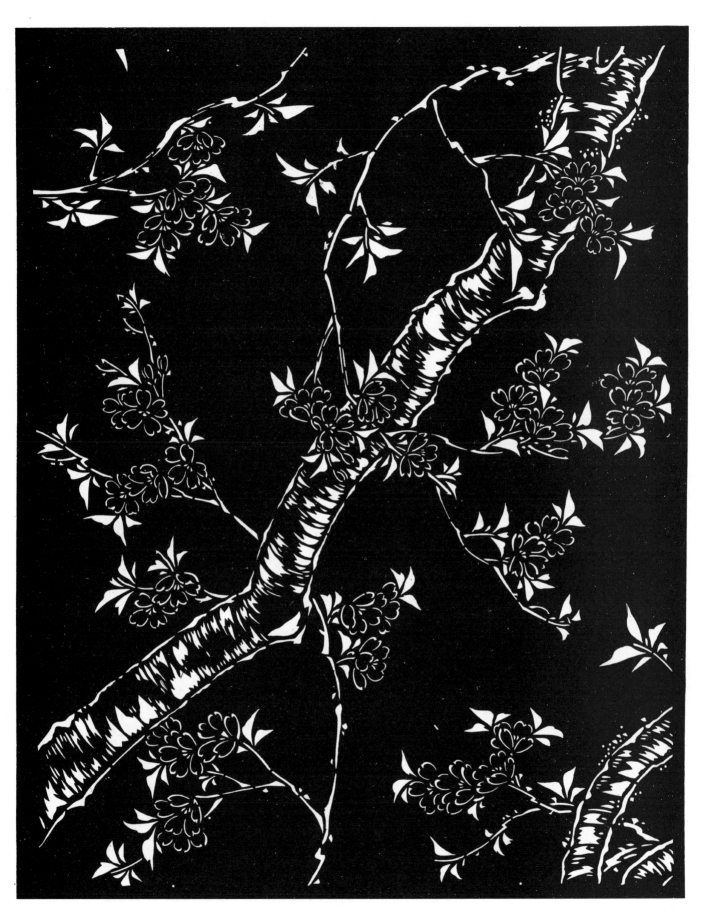

3. A Cherry Tree in Bloom

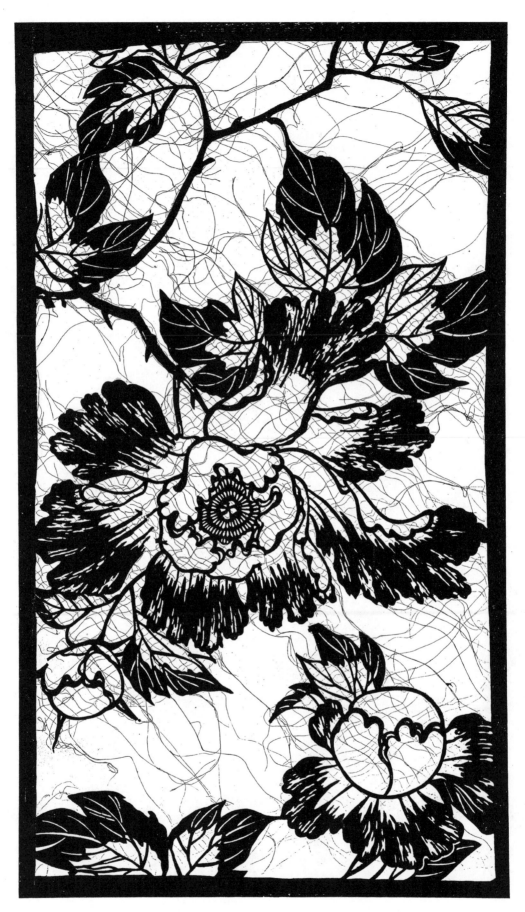

4. Peony Blooms and Buds

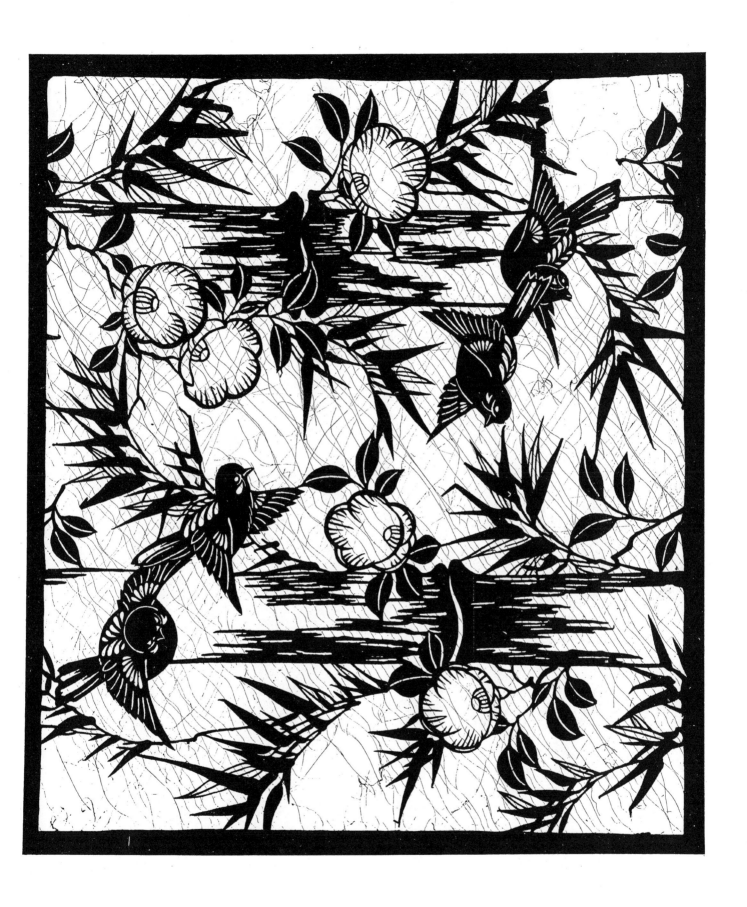

5. **Bamboo, Camellias, and Sparrows**

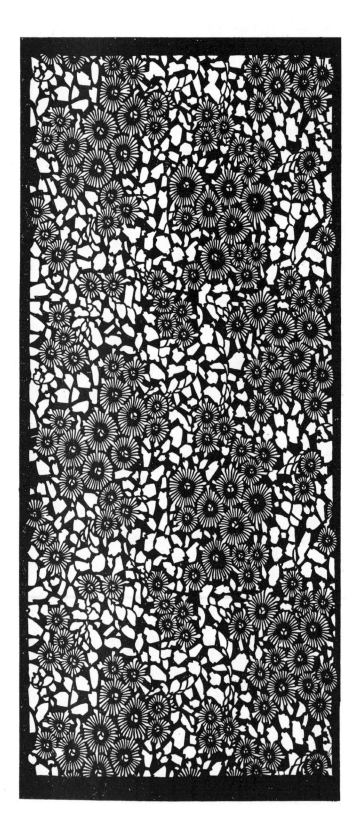

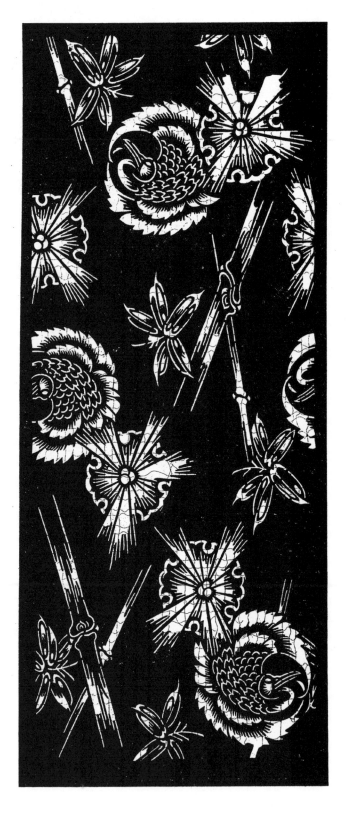

6. **Pine Needles and Buds on a Rocky Ground**

7. **Bamboo Rods, Pine Needles on Snow Rosettes and Circular Cranes (Symbols of Luck)**

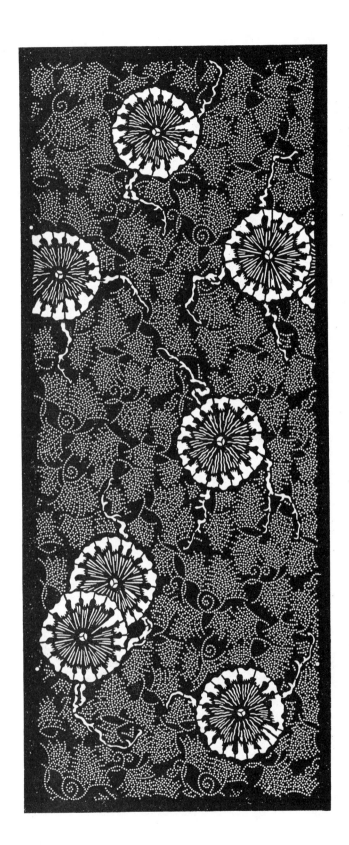

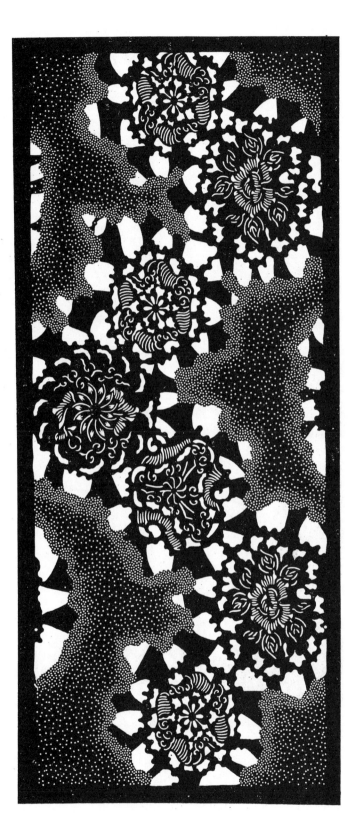

8. **Rosette-Shaped Young Pine Motifs (With Roots) Situated among Ferns (Symbol of the New Year)**

9. **Floral Motifs on Cloud Background**

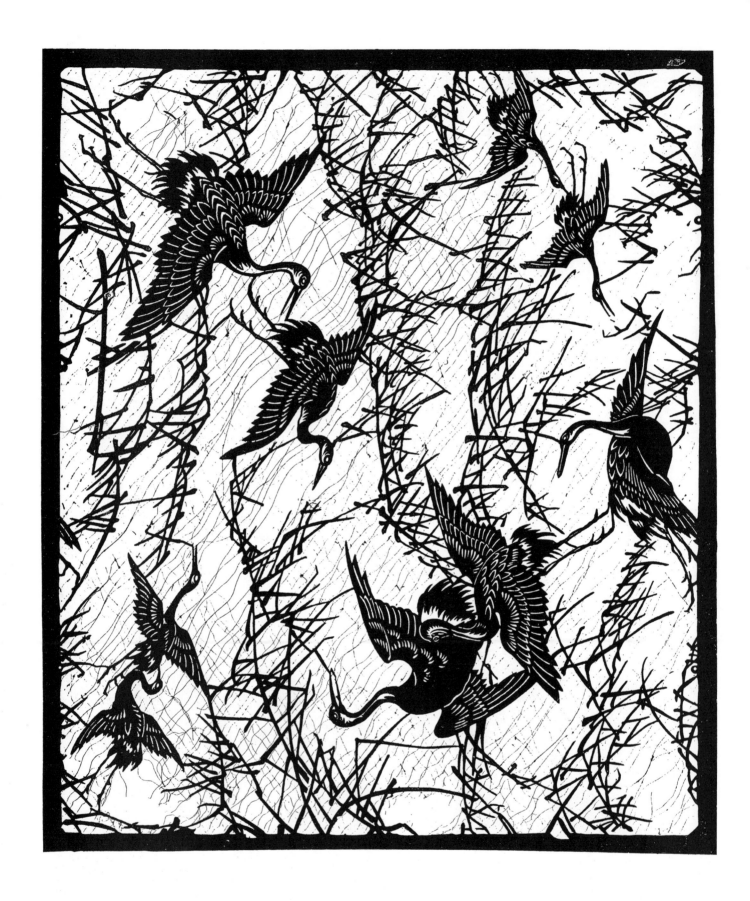

10. Cranes and Autumnal Reeds

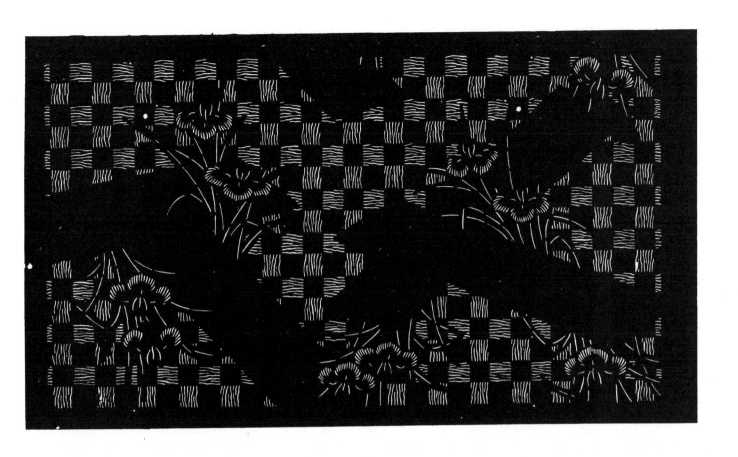

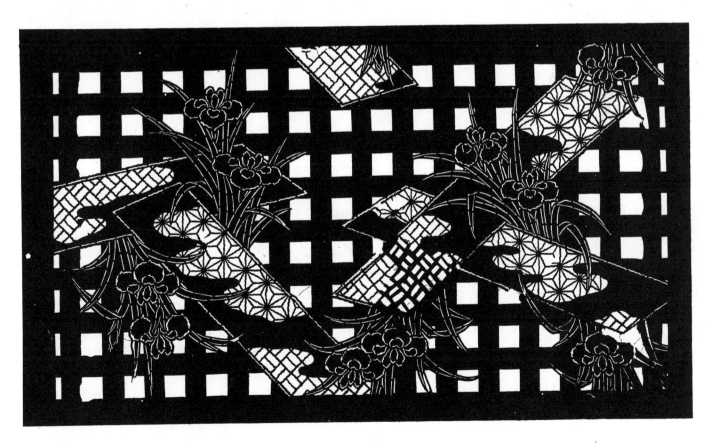

11. Bridge Patterns in a Swamp of Irises

12. Wickerwork; Matching Stencil
Pair for Two-Tone Decoration

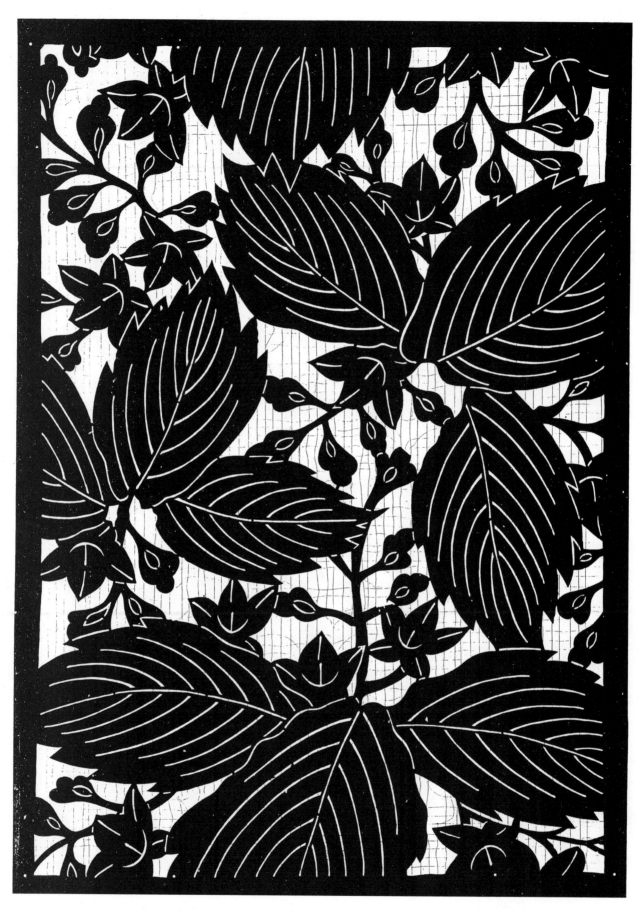

13. Blooming Branches of a Kiri Tree (*Paulownia imperialis*)

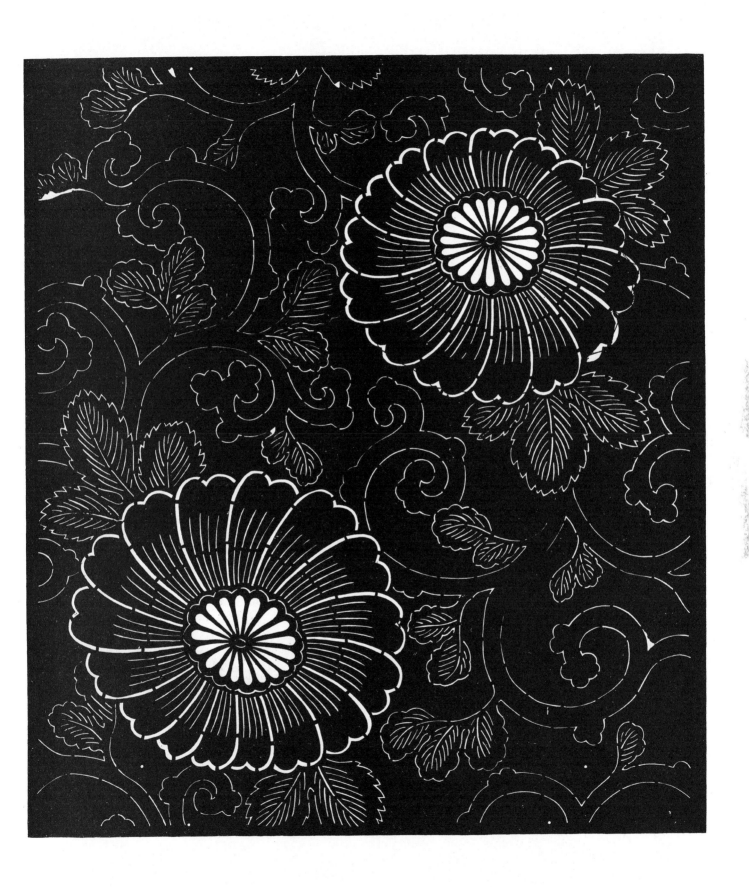

14. Karakusa: Stylized Chrysanthemums in a Chinese Style

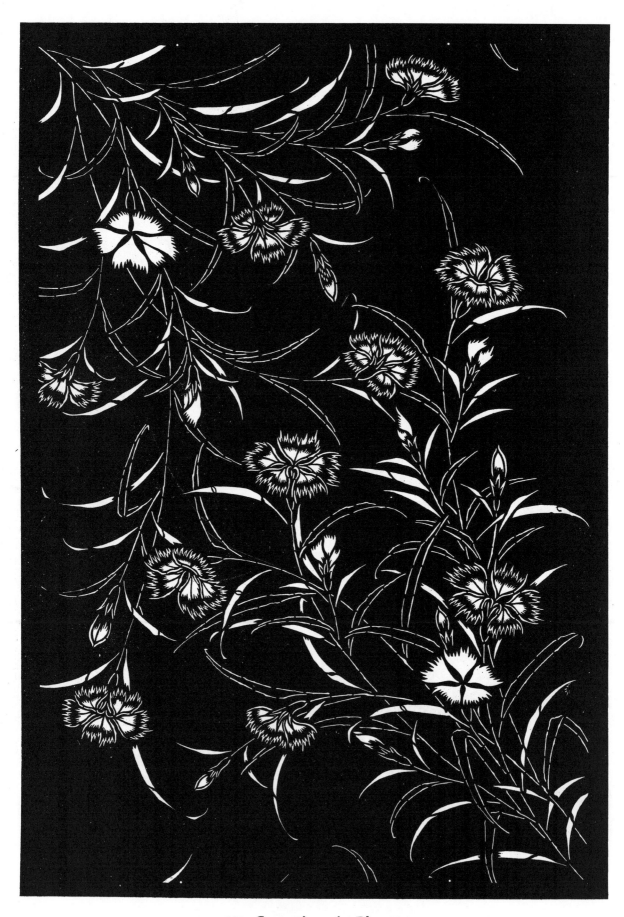

15. Carnations in Bloom

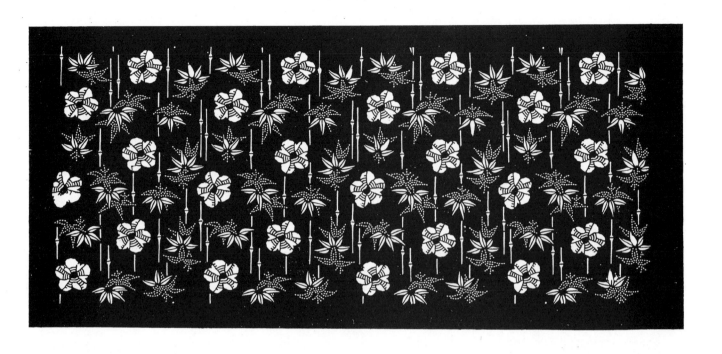

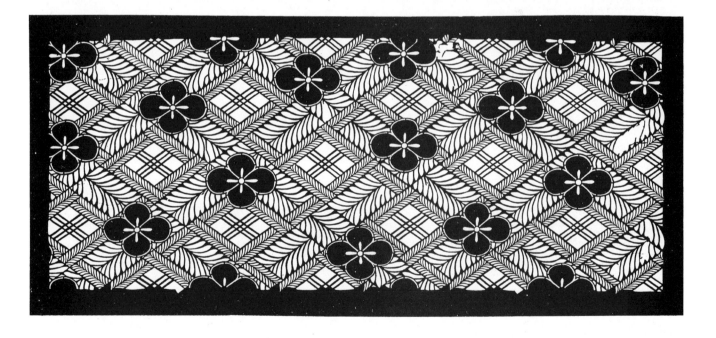

16. **Bamboo and Mum Blooms** 17. **Hishi Blooms on a Diamond-Scored Background**

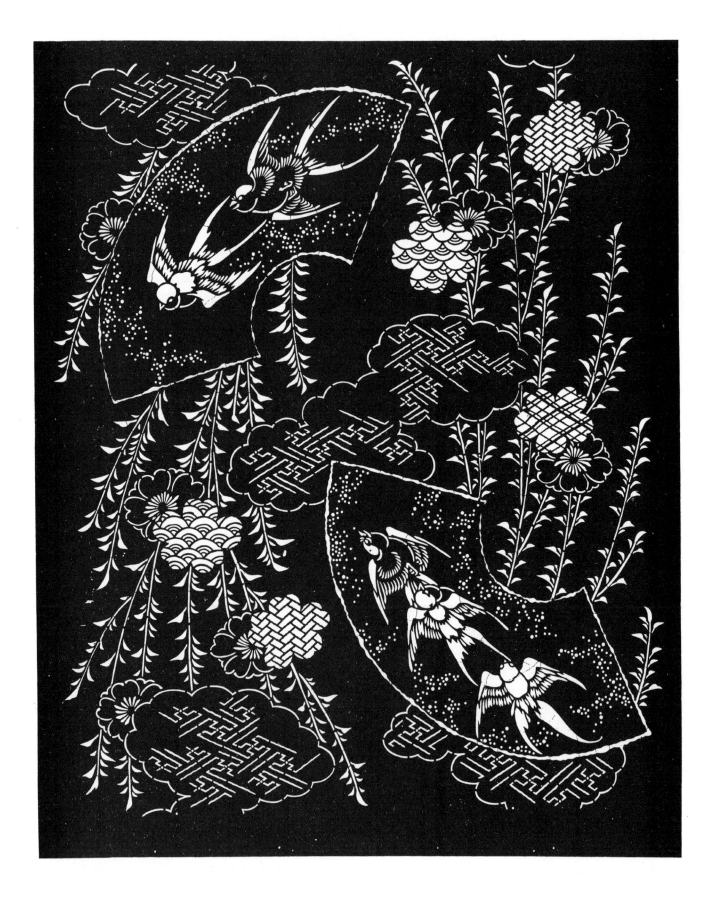

18. Branches of the Hanging Cherry Tree (Blooms with Various Inner Patterns); Fans with Swallows, Clouds with Cross Patterns

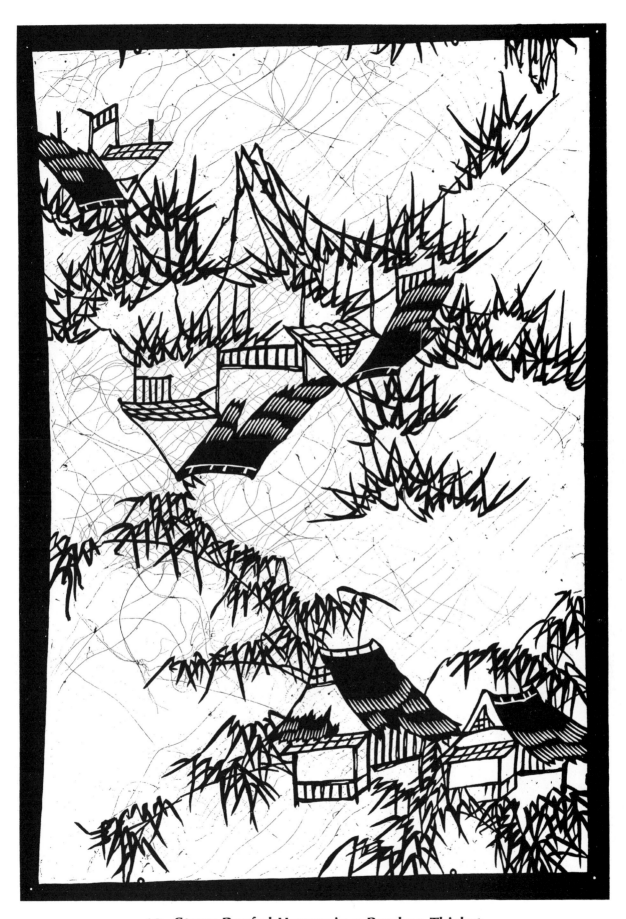

19. **Straw-Roofed Houses in a Bamboo Thicket**

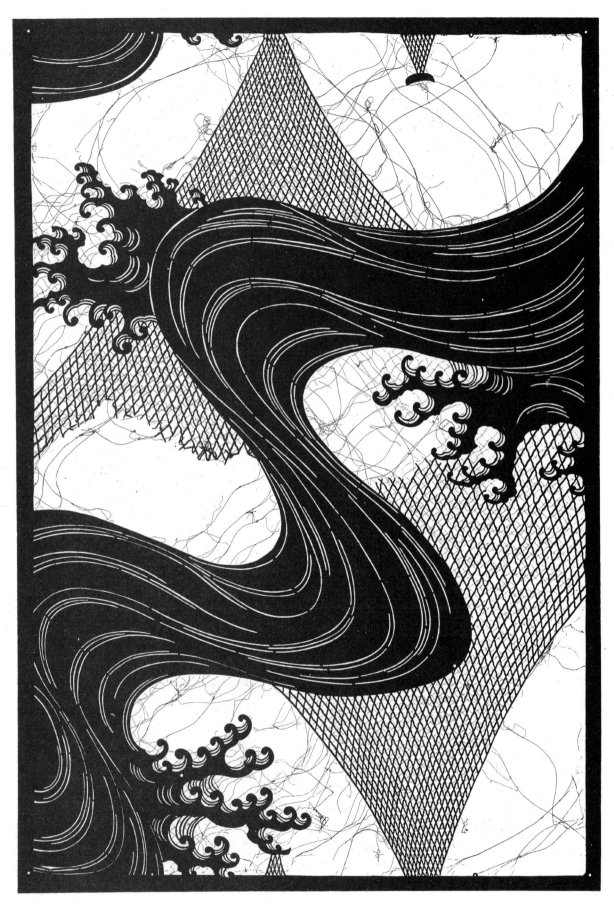

20. **Nets Hung Out to Dry; Waves**

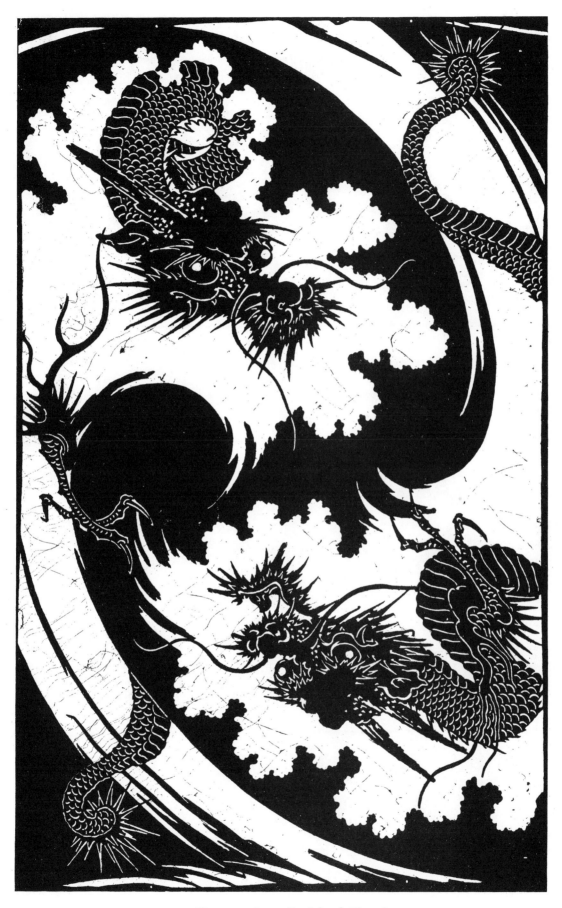

21. Dragon in a Swirl of Clouds

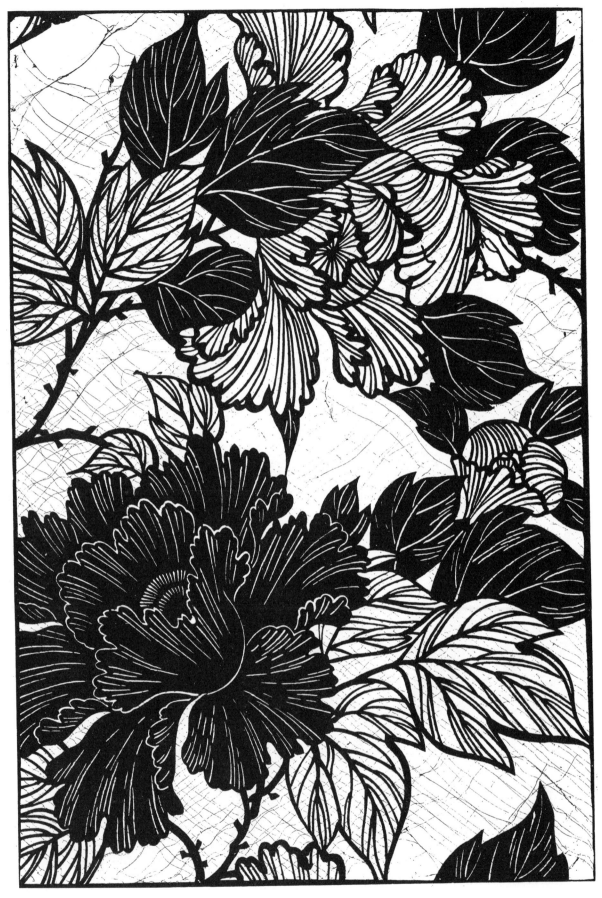

22. Peony Blooms

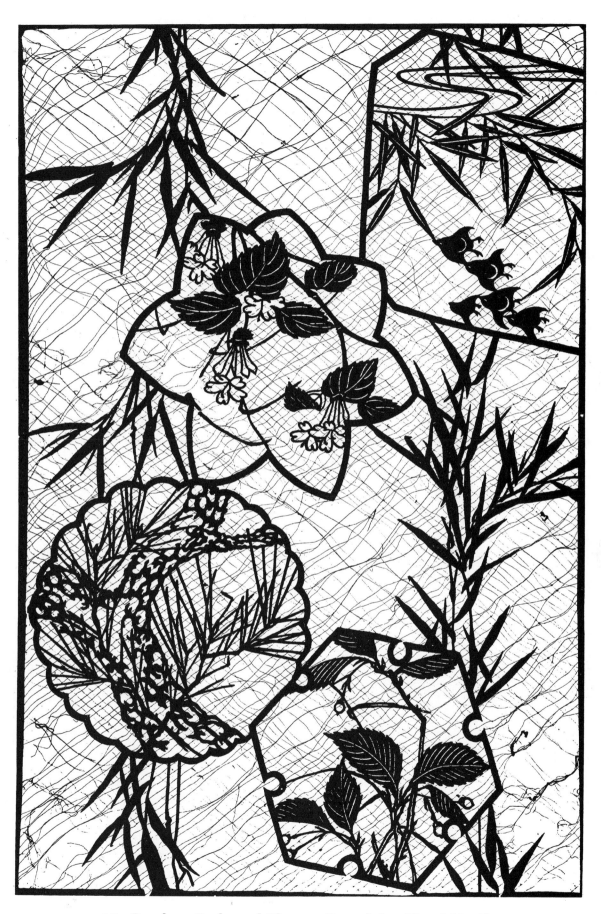

23. Bamboo Rods and Shapes Containing Floral Motifs

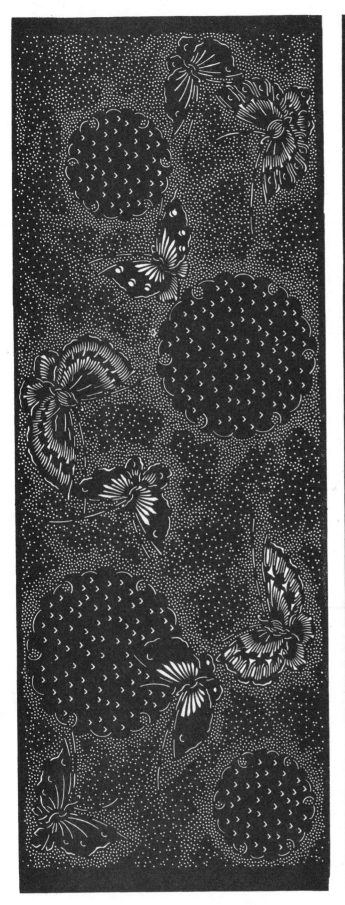

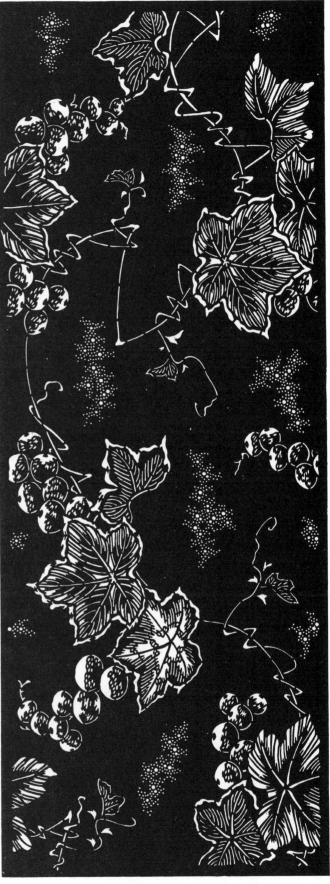

24. Butterflies on a Background of Dotted Clouds

25. Grapevines

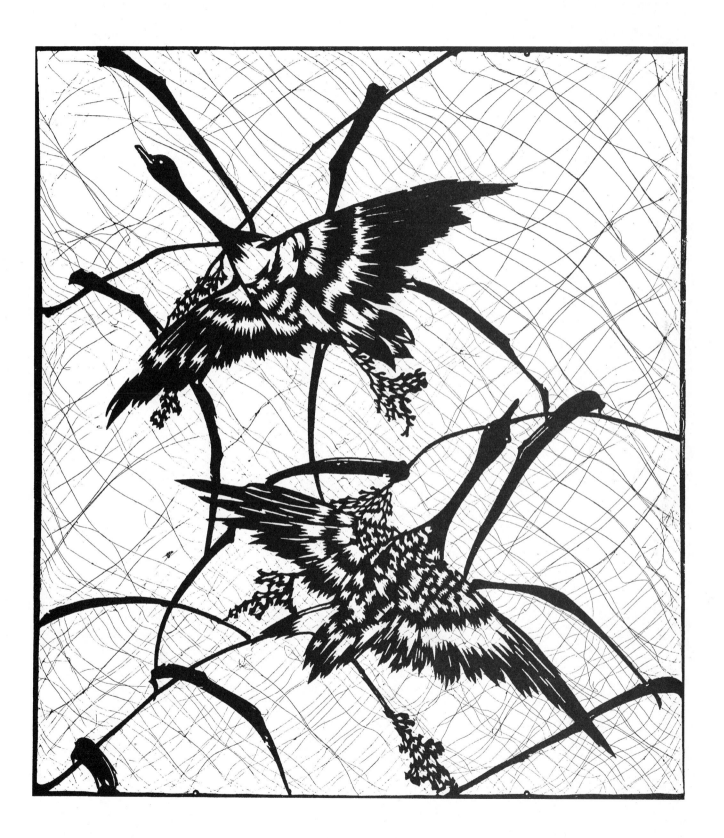

26. Wild Geese and Reeds

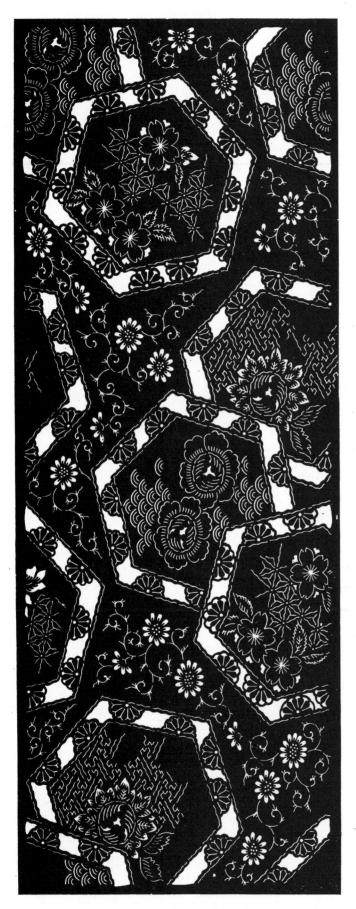

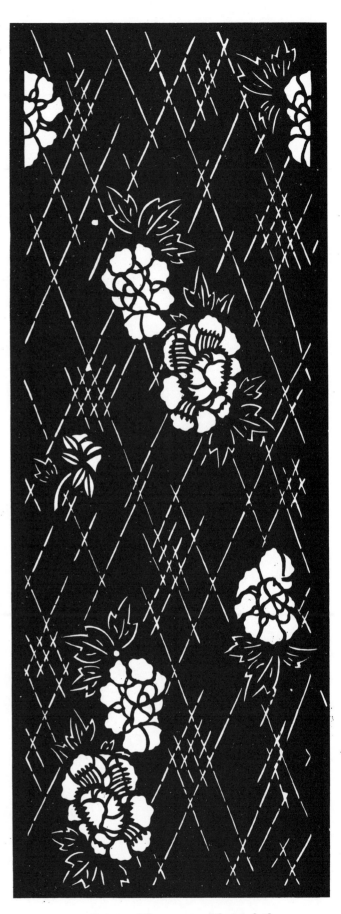

27. Hexagonal Fields with Blooms and Basic Patterns (In Karakusa Style)

28. Peony Blooms with Lightly Scored Background

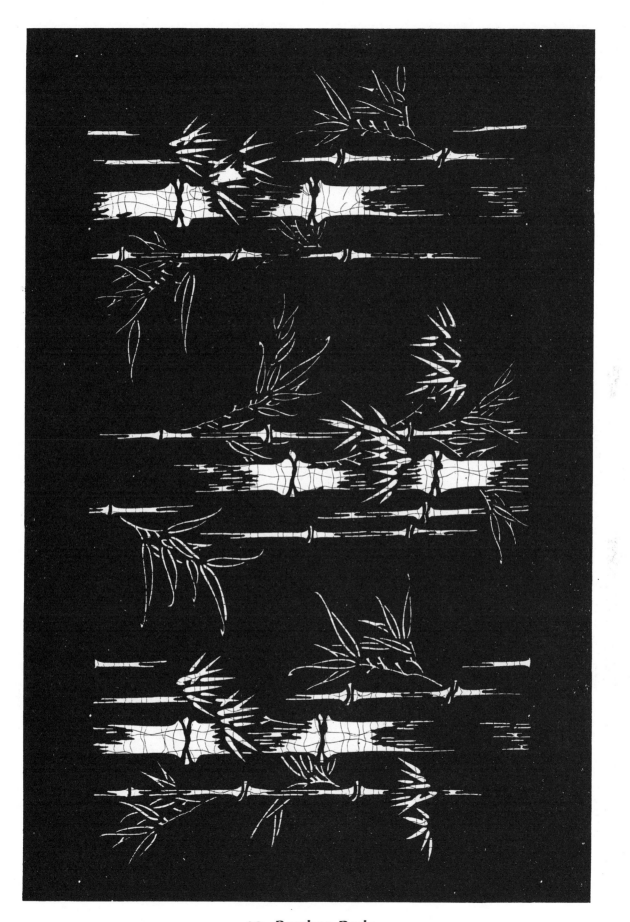

29. Bamboo Rods

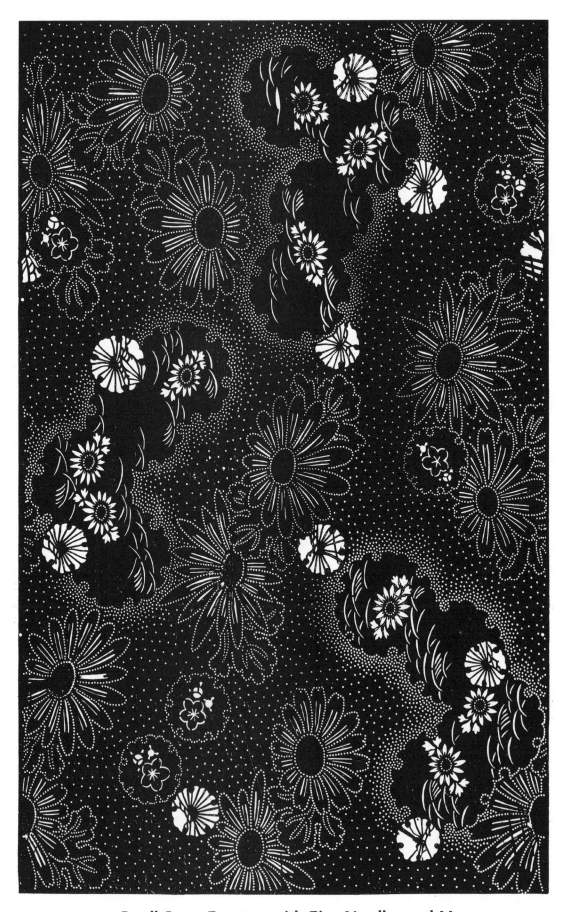

30. Small Snow Rosettes with Pine Needles and Mums

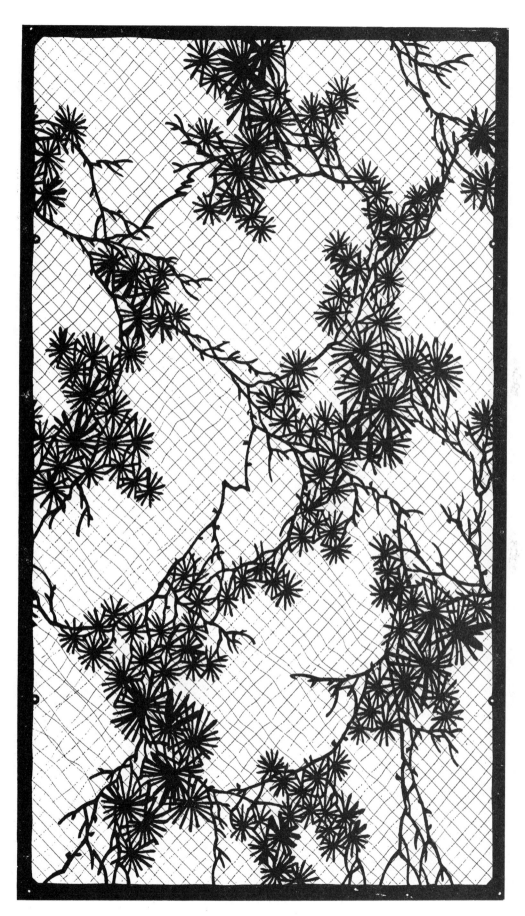

31. Pine Branches

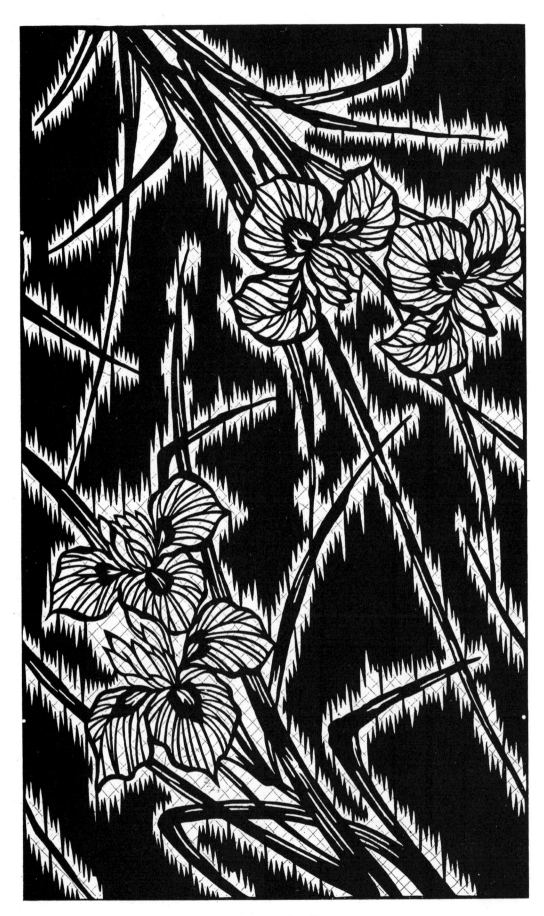

32. Sword Lilies

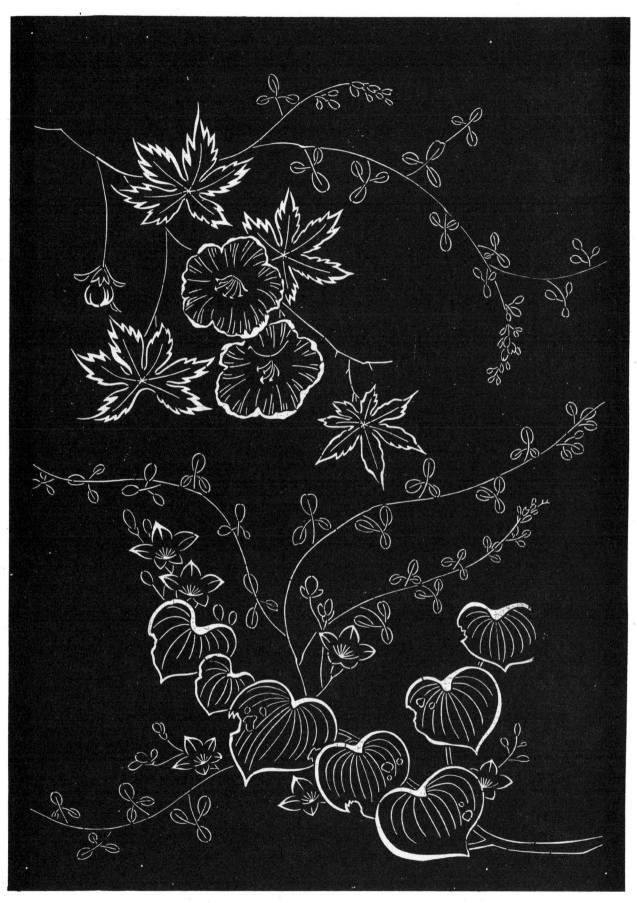

33. **Monochoria, Okra Flowers, Hagi Branches**

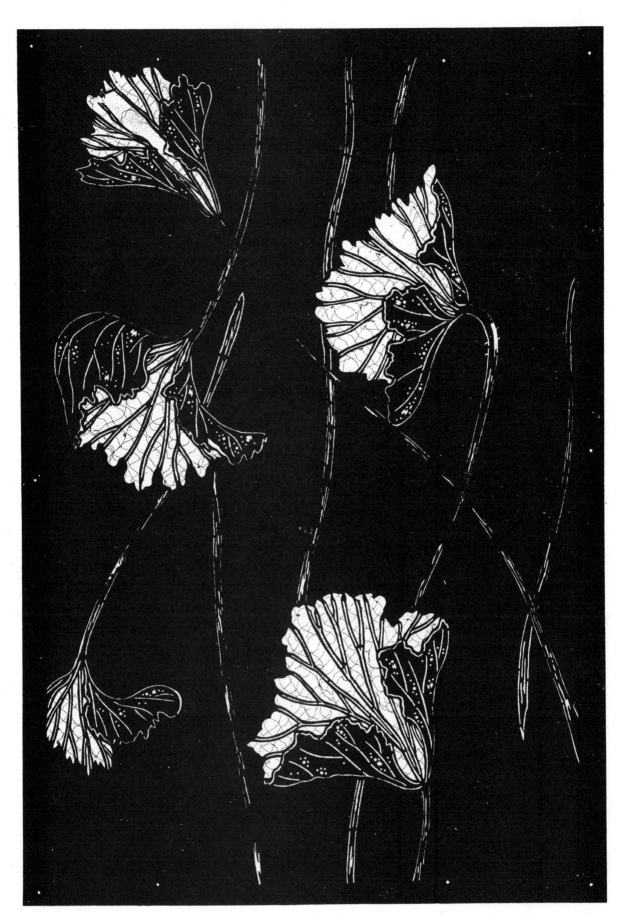

34. Coltsfoot

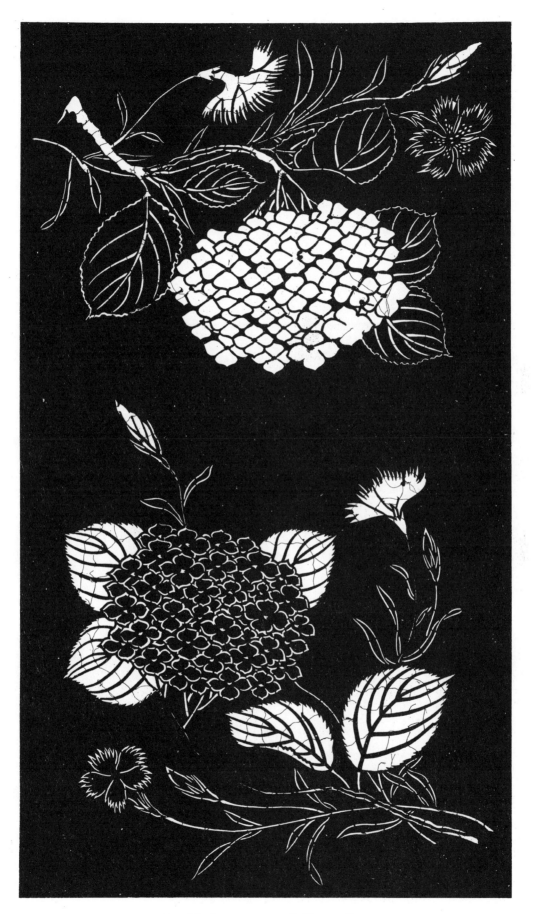

35. **Hydrangea and Carnations**

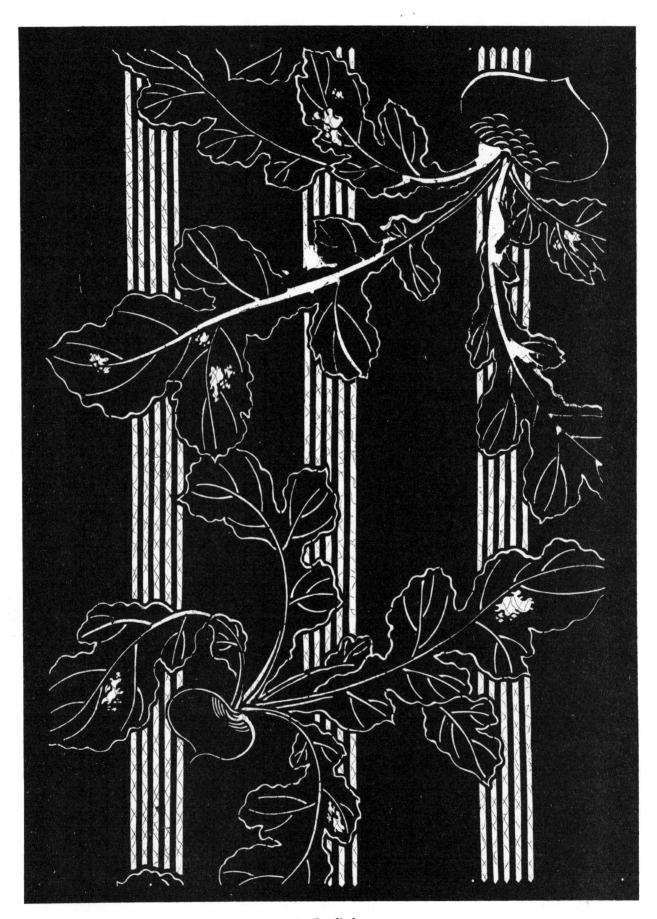

36. Radishes

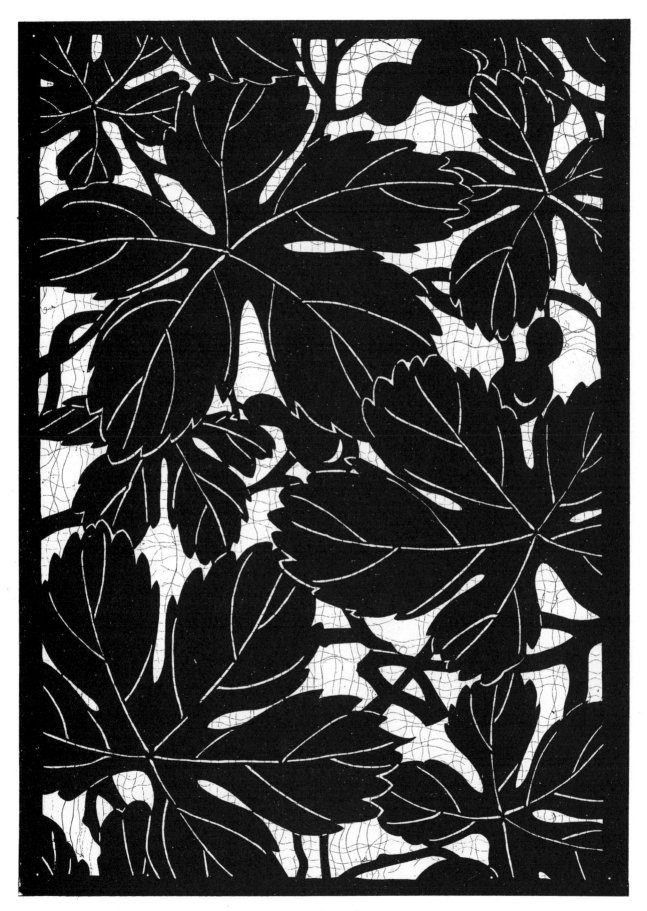

37. Gourds

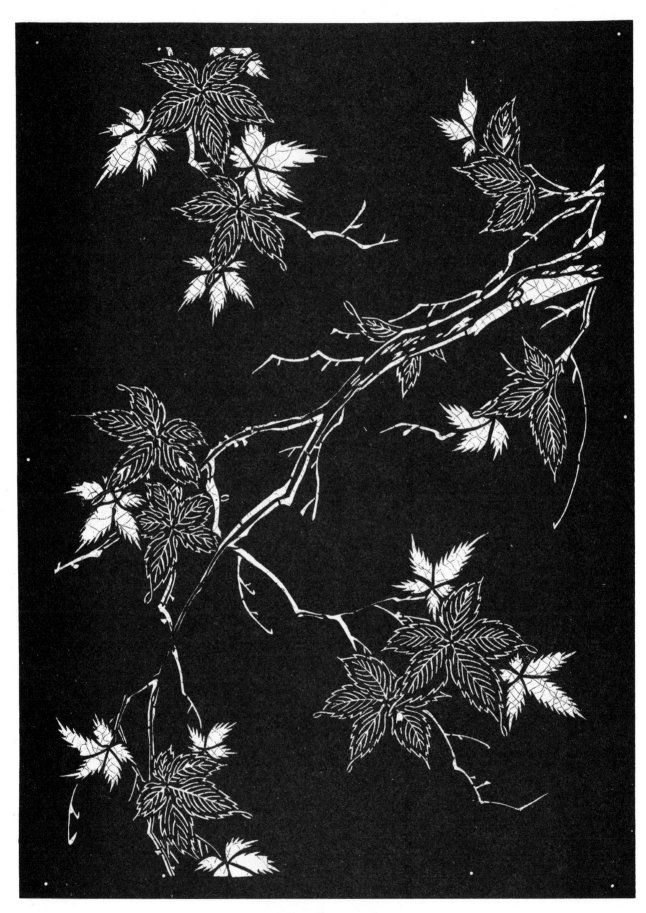

38. Maple Branches

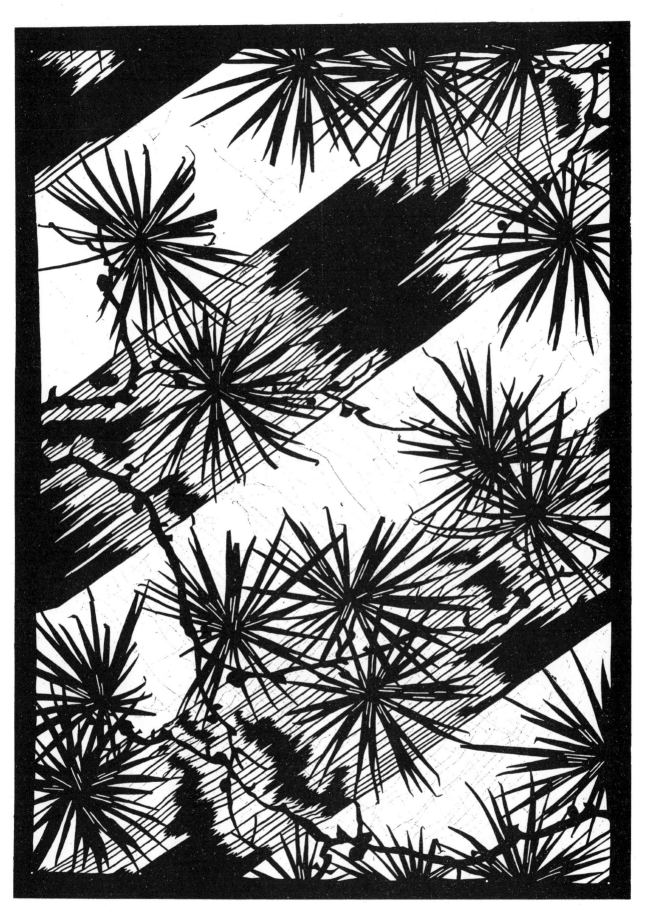

39. Pine Branches and Spotted Bamboo Rods

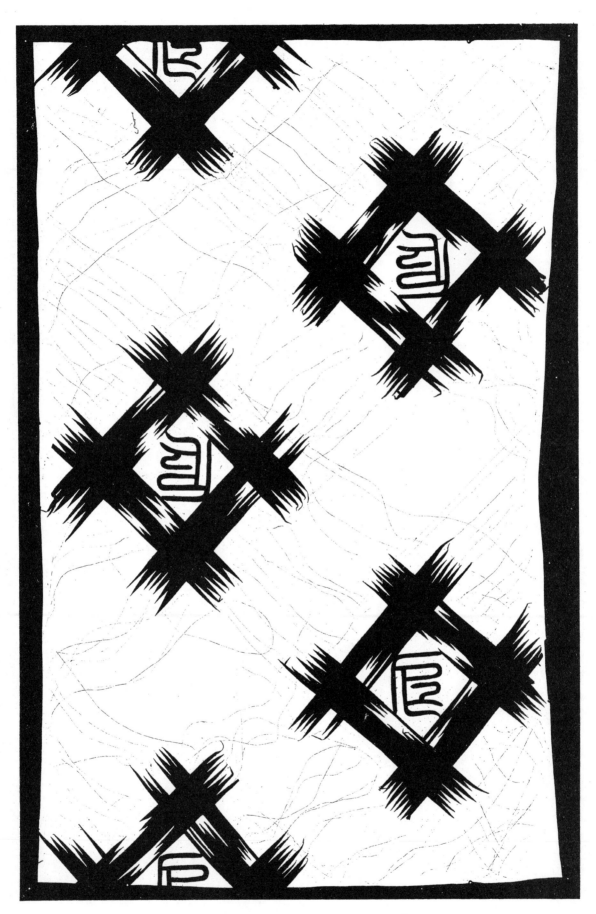

40. Well Openings Containing the Character "Tatsu" (Dragon)

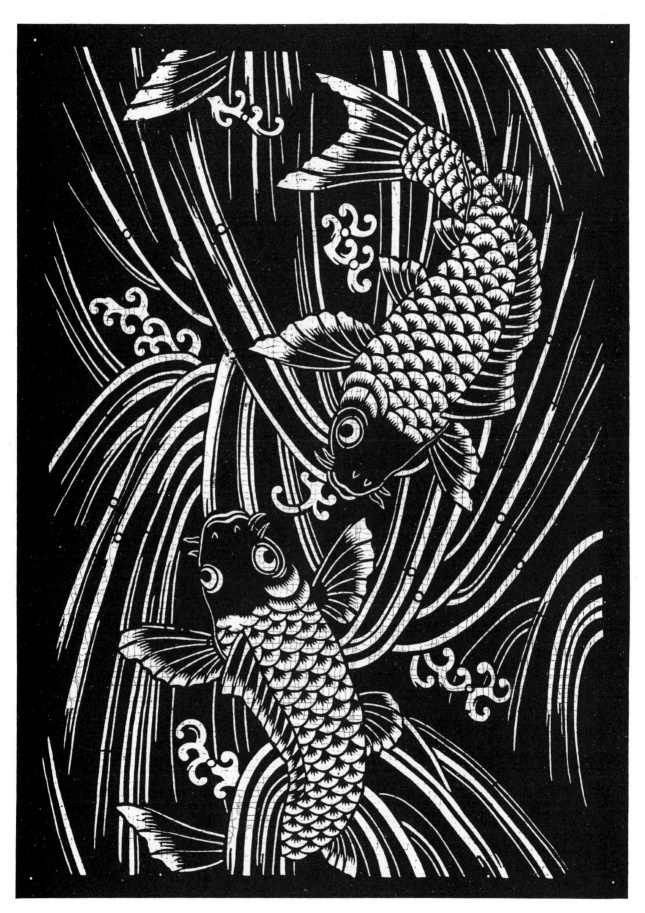

41. Fish in a Whirlpool

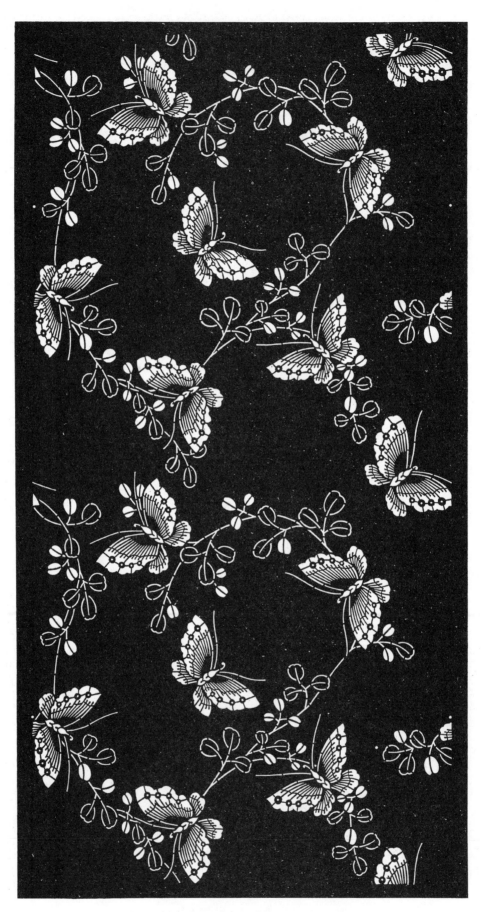

42. Butterflies and Hagi Branches

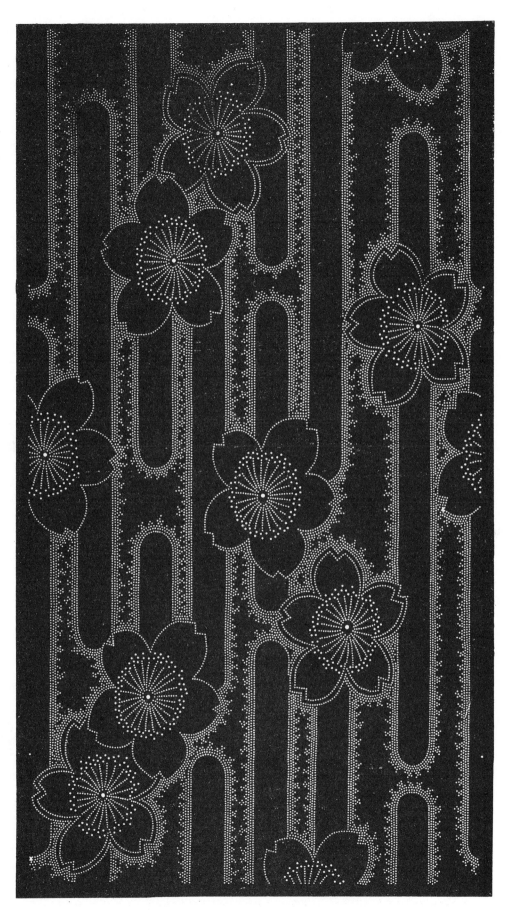

43. Cherry Blooms with a Stripe Pattern

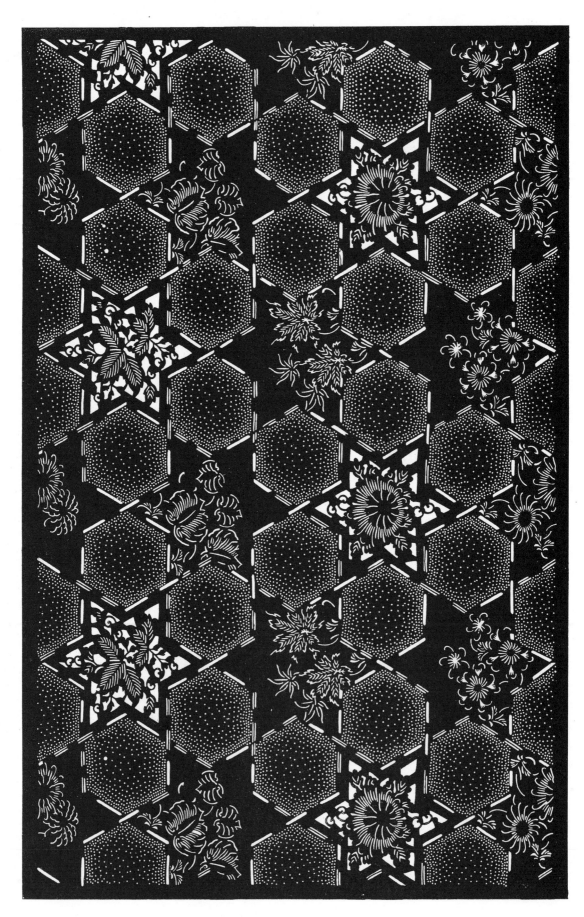

44. Star Pattern with Floral Motifs

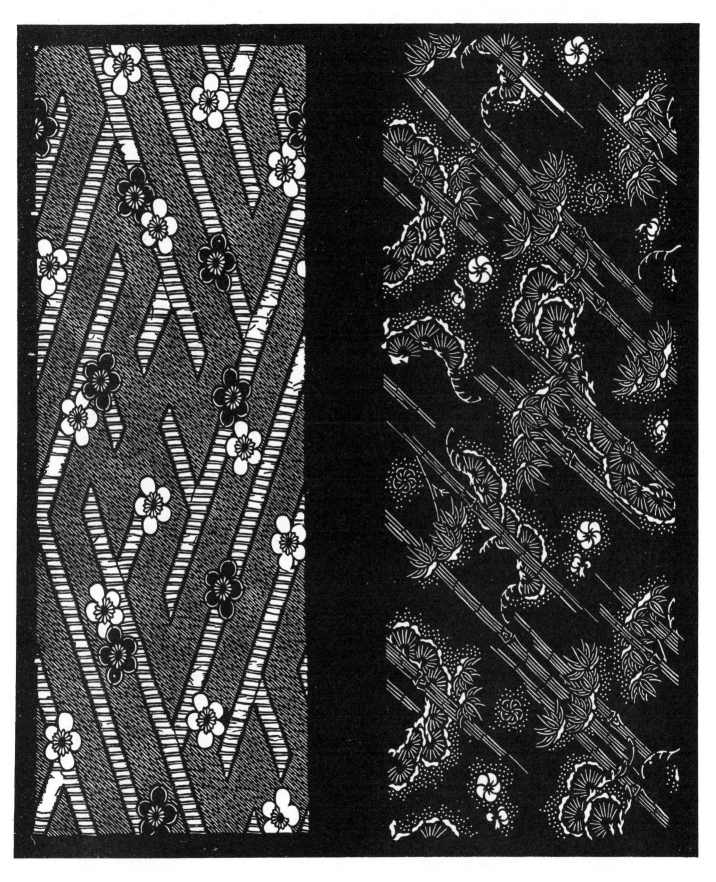

45. Mum Blooms with Diagonal Stripes

46. Pine, Bamboo, and Mums in Snow

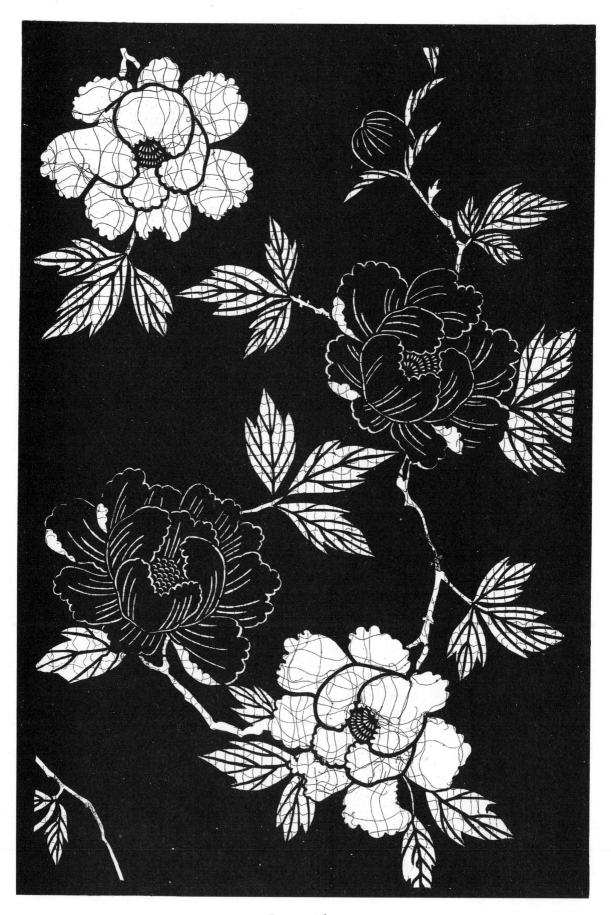

47. Peony Flowers

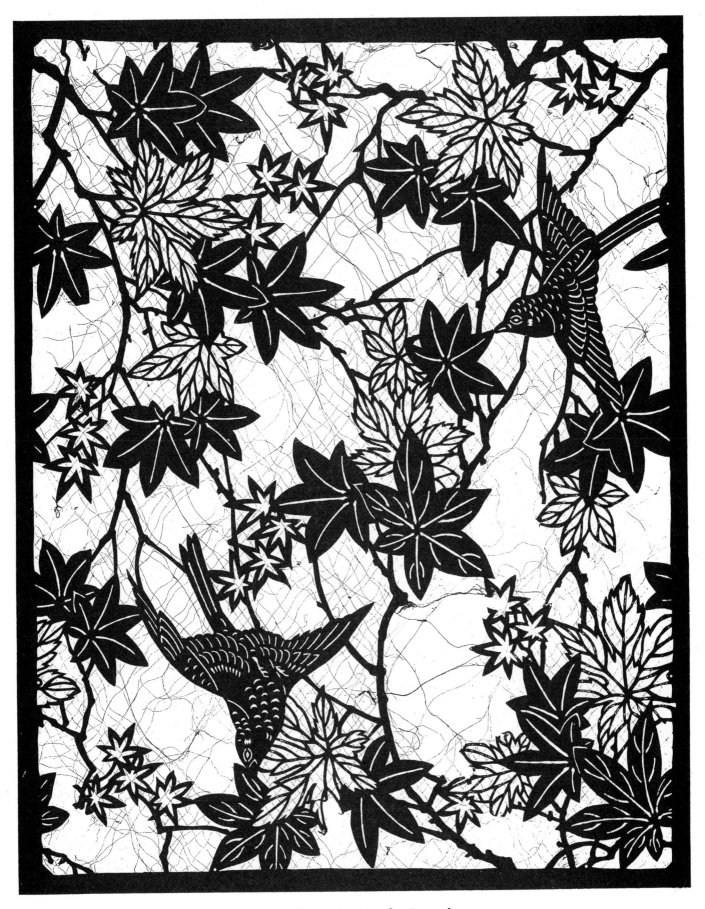

48. Swallows in Maple Branches

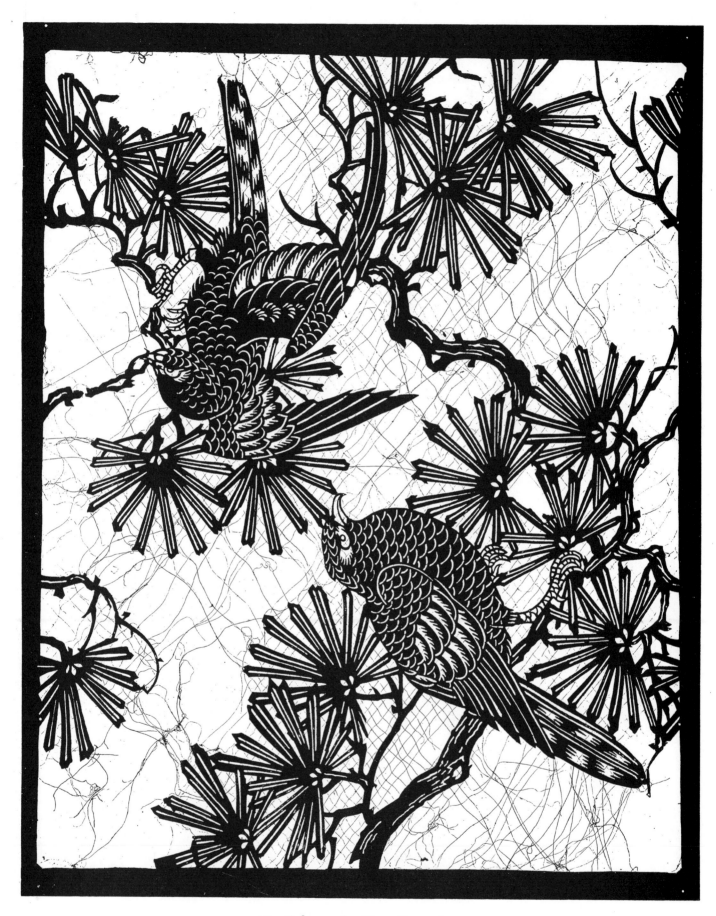

49. Falcons in Pine Branches

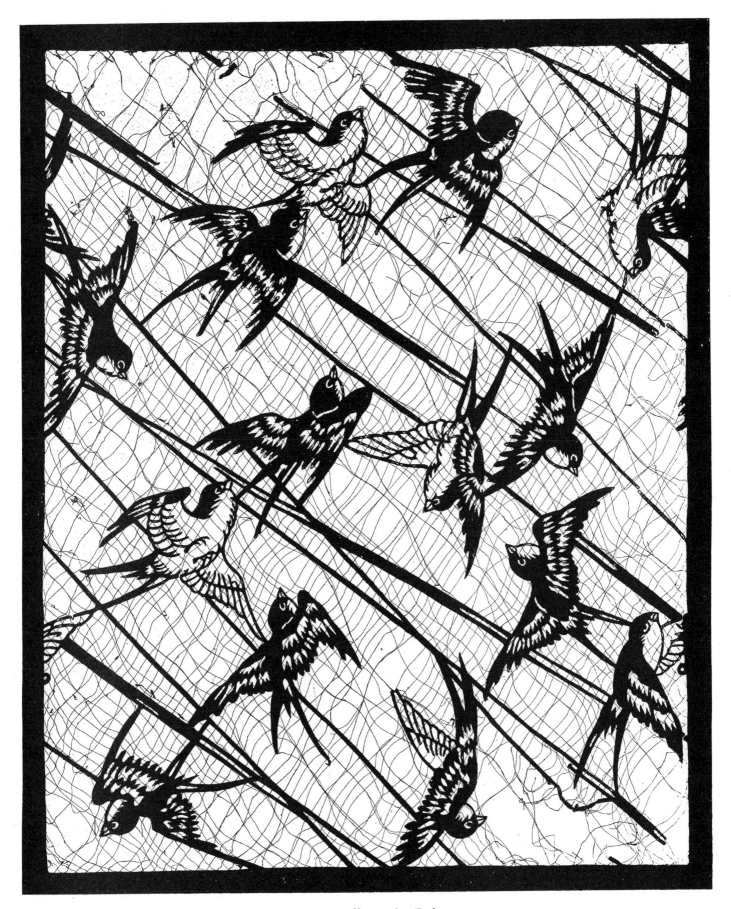

50. Swallows in Rain

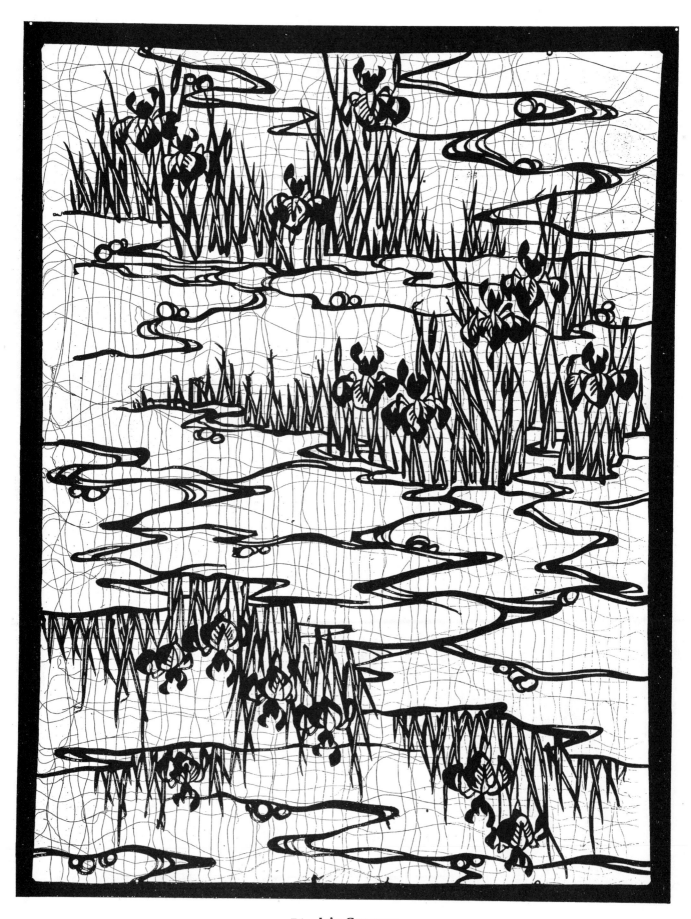

51. Iris Swamp

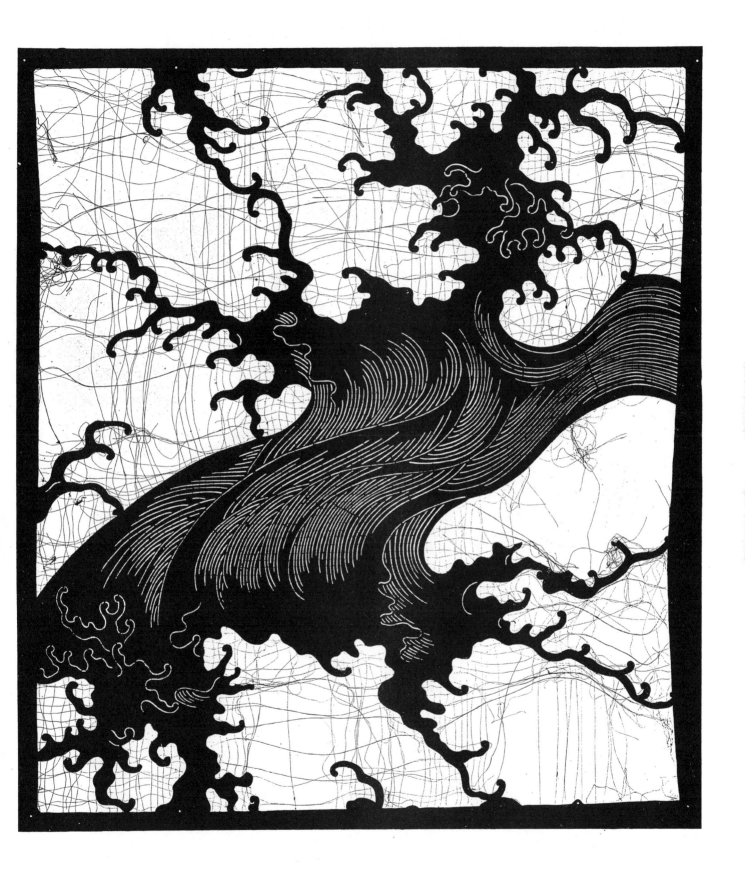

52. Waves

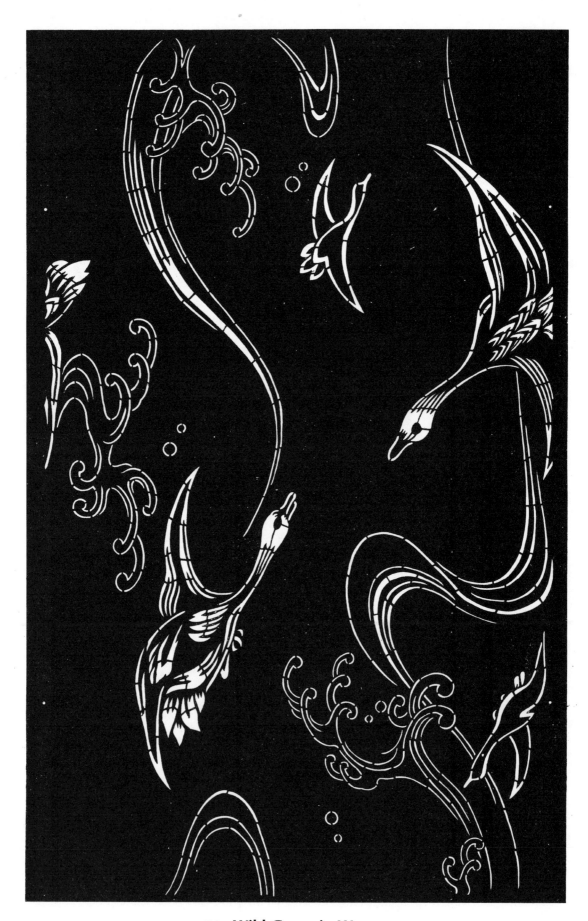

53. Wild Geese in Waves

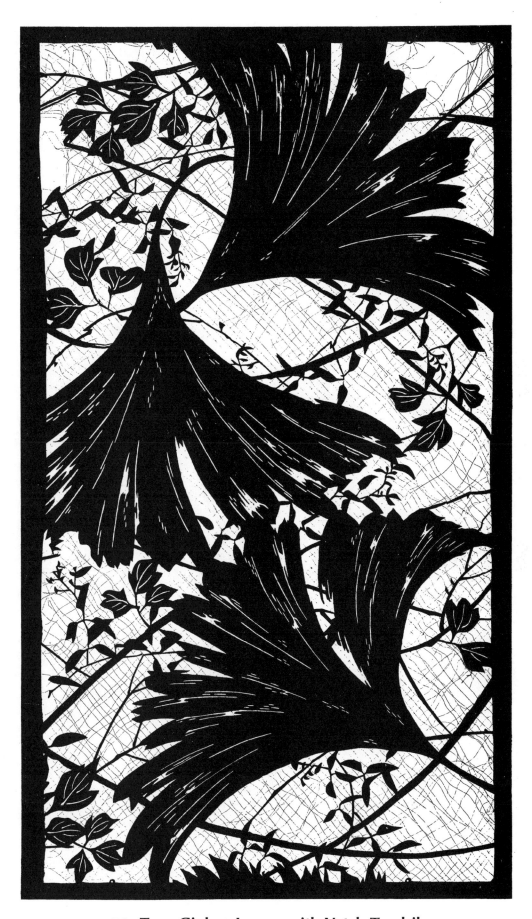

54. Torn Ginkgo Leaves with Vetch Tendrils

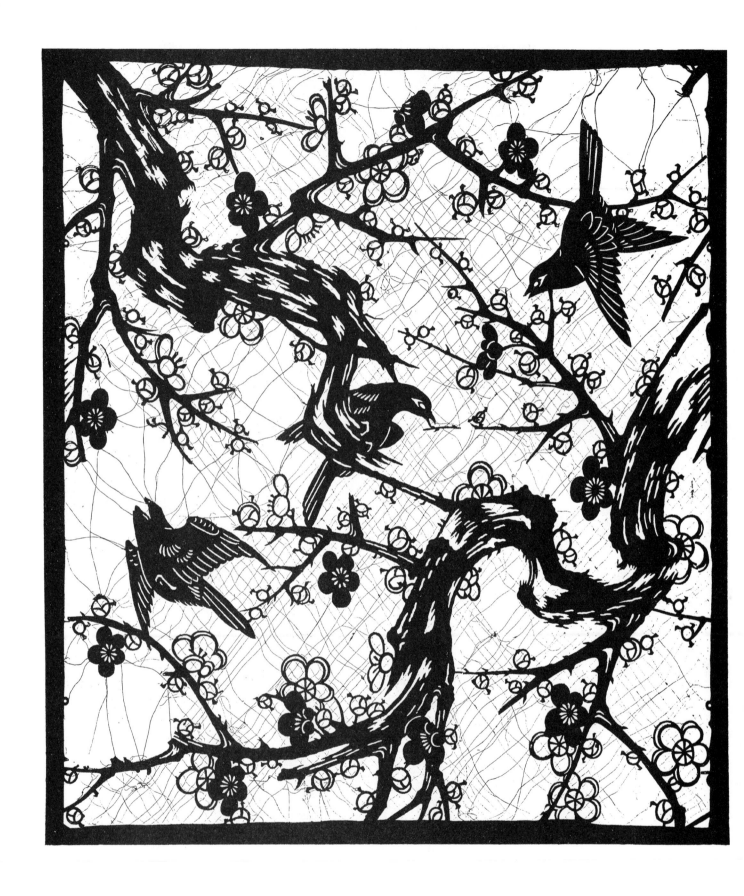

55. Nightingales in a Blooming Mum Tree

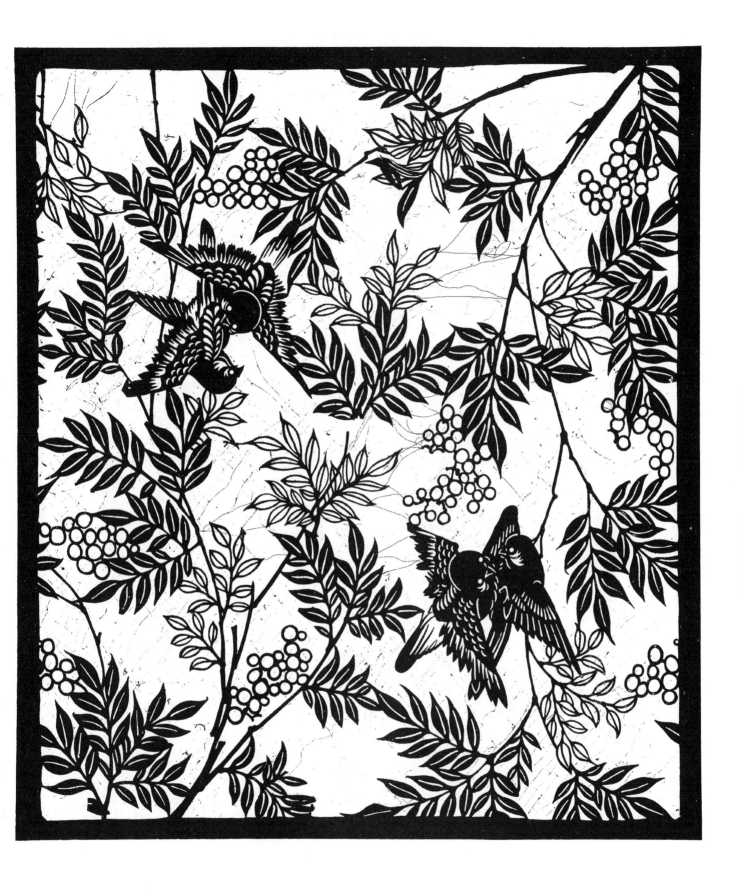

56. Nandina and Sparrows

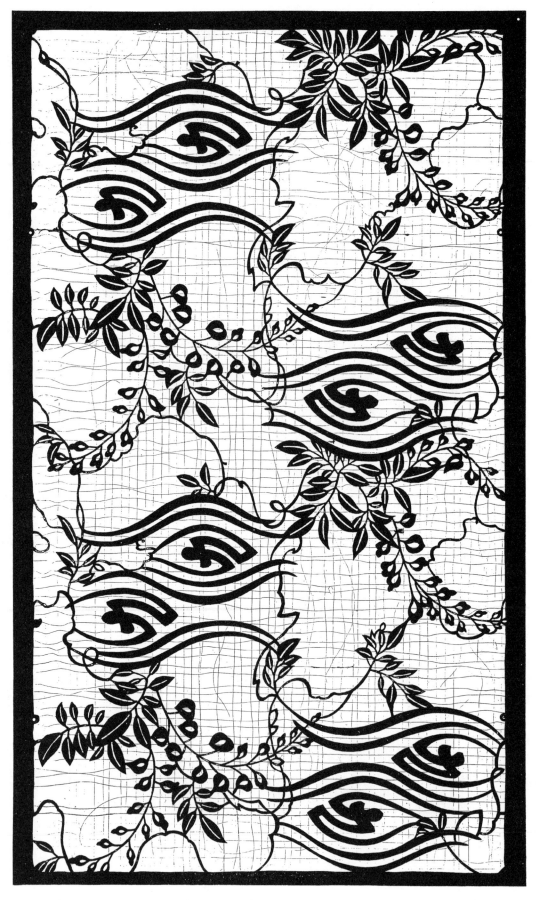

57. **Glycine Flowers with Pairs of Written Characters (Meaning "Nine")**

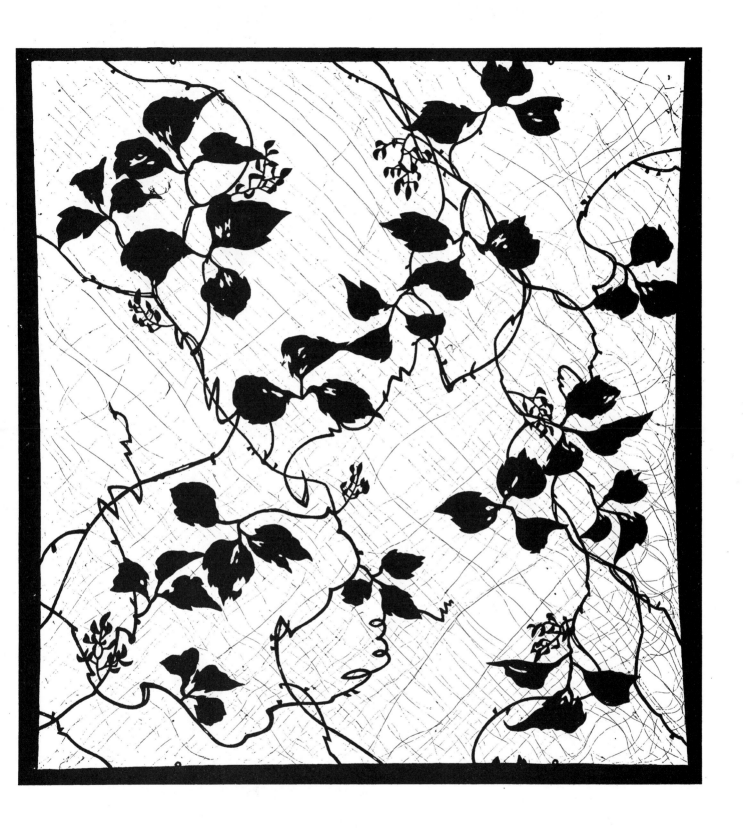

58. Vetch Tendrils

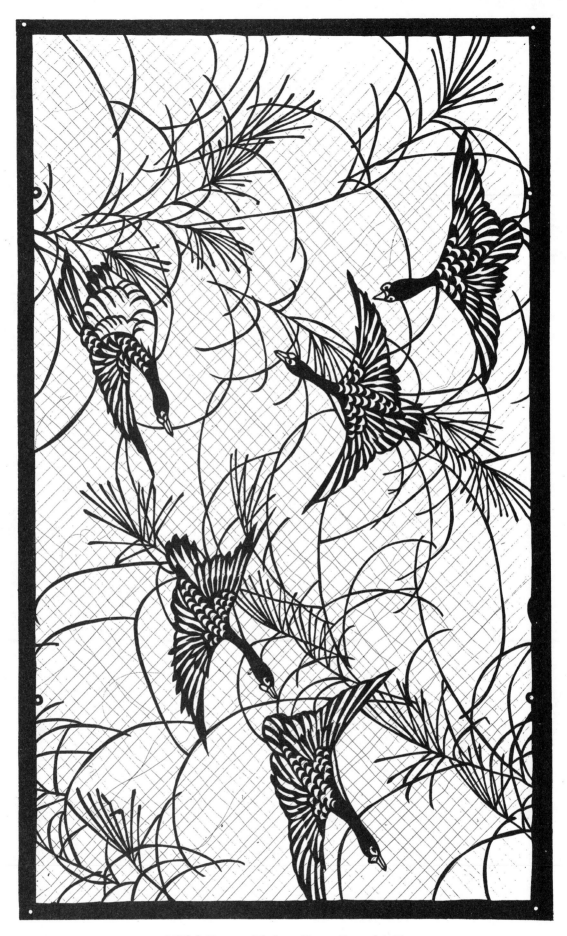

59. Wild Geese Flying Over Susuki Grass

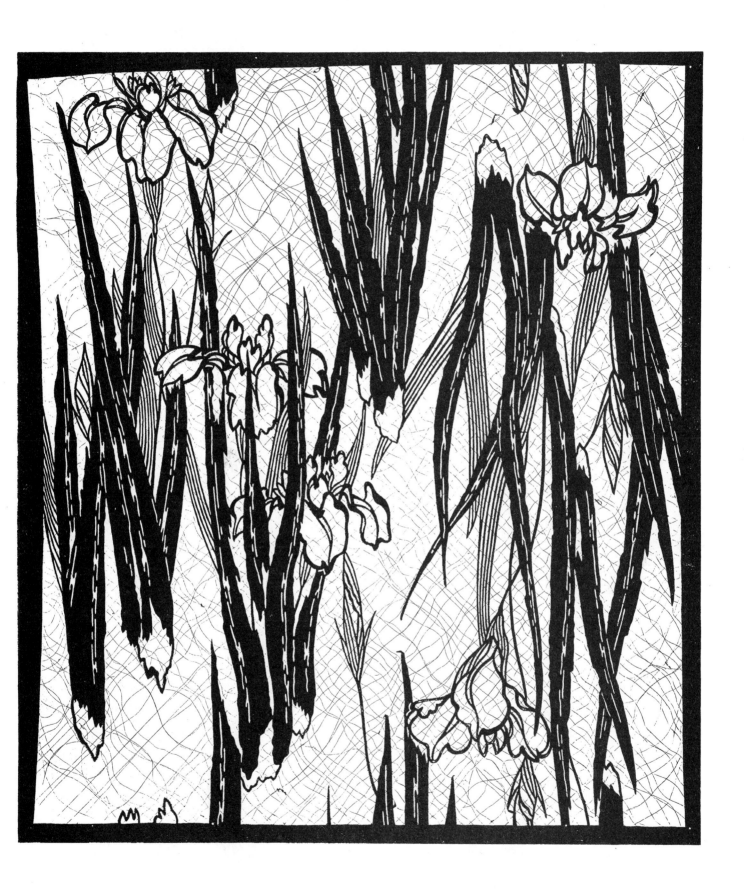

60. Blooming Sword Lilies

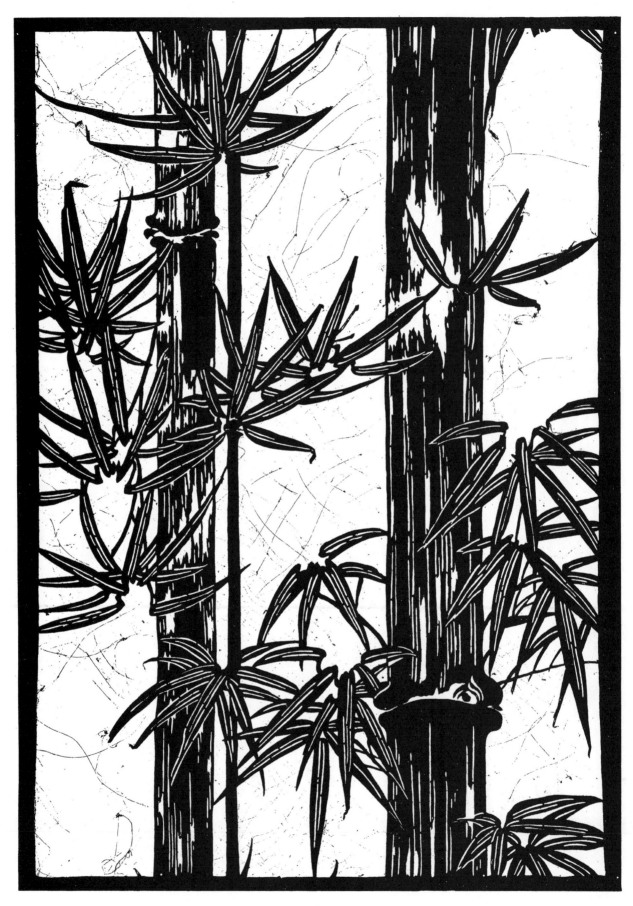

61. Bamboo Trees

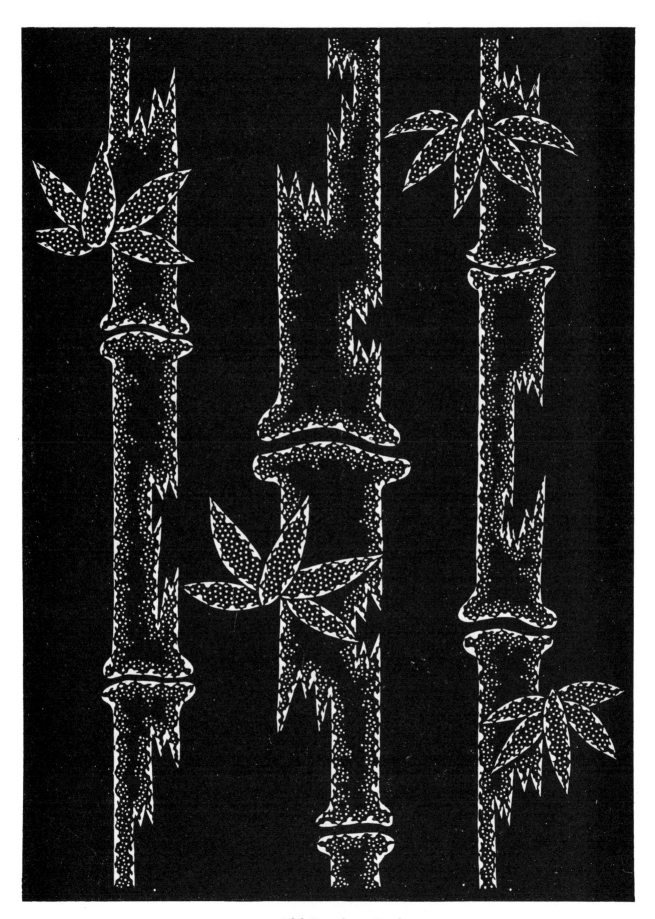

62. Old Bamboo Rods

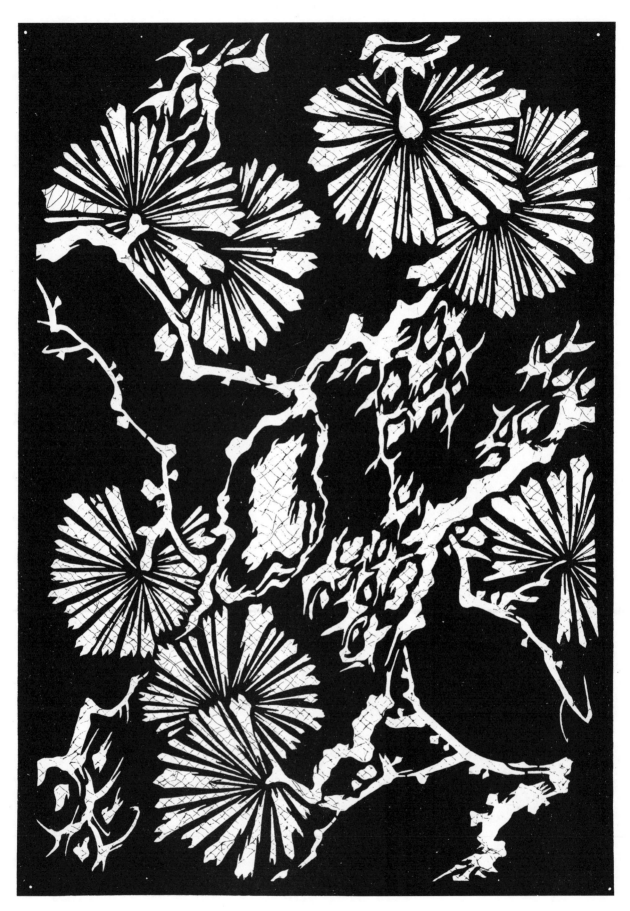

63. Pine

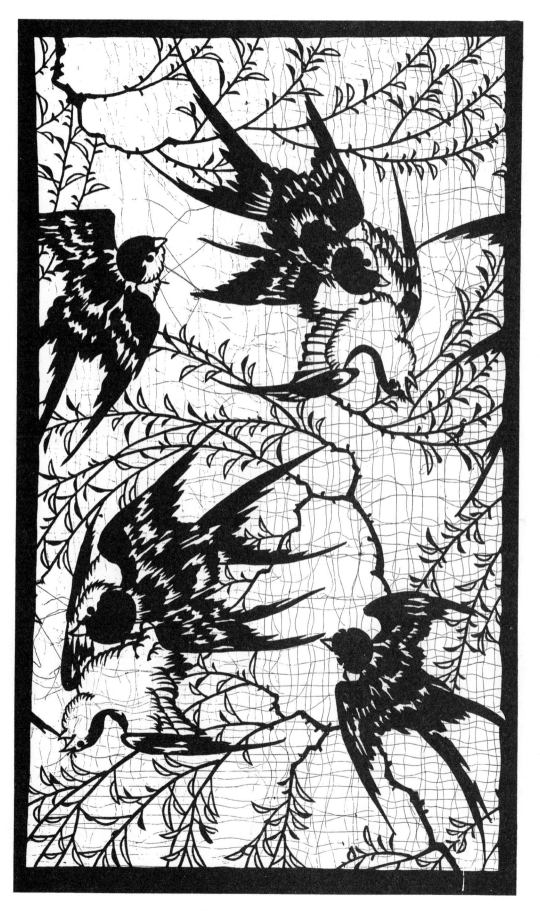

64. Swallows and Weeping Willows

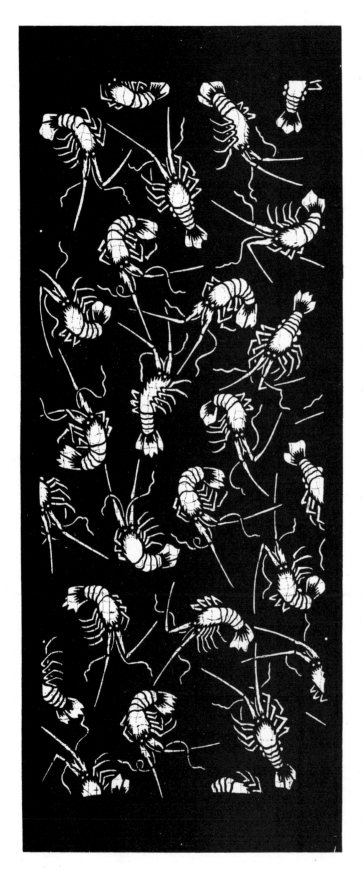

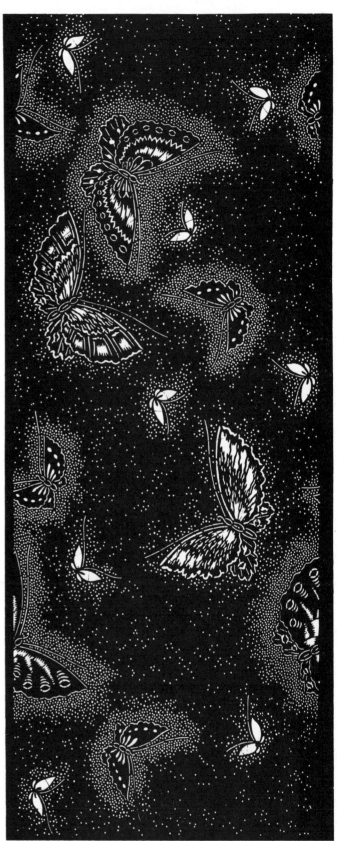

65. Lobsters

66. Butterflies

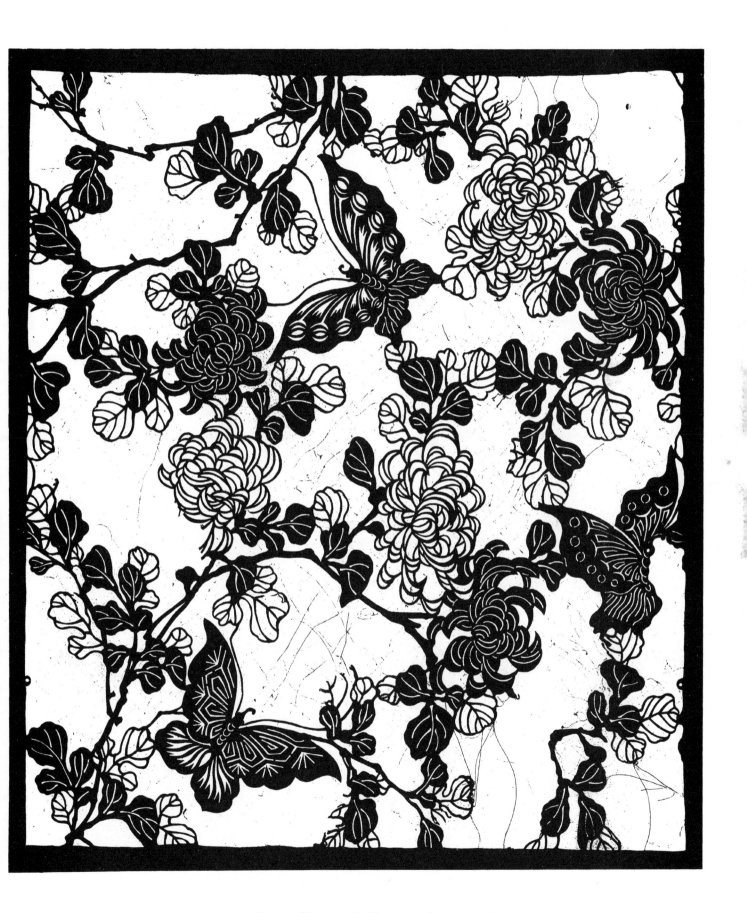

67. Butterflies and Chrysanthemums

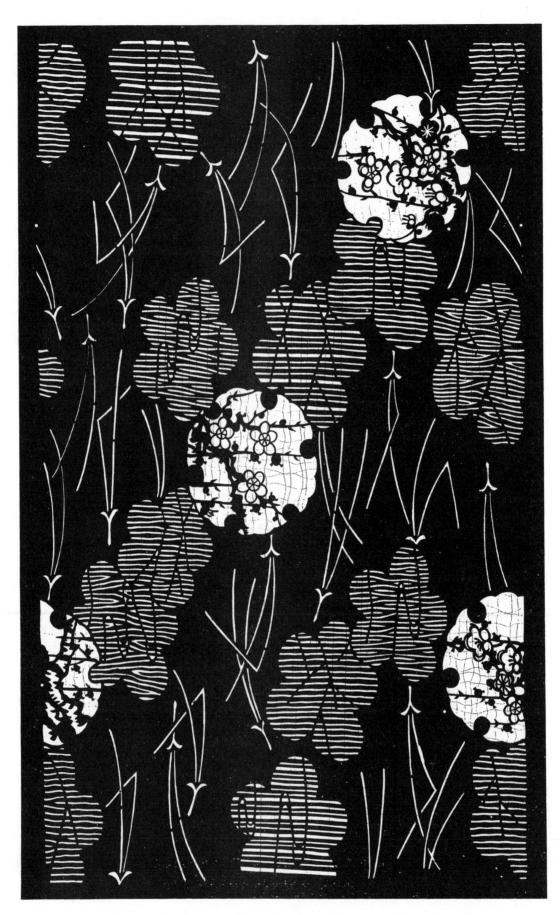

68. Snow (In Rosette Form), Mum Flowers, Pine Needles

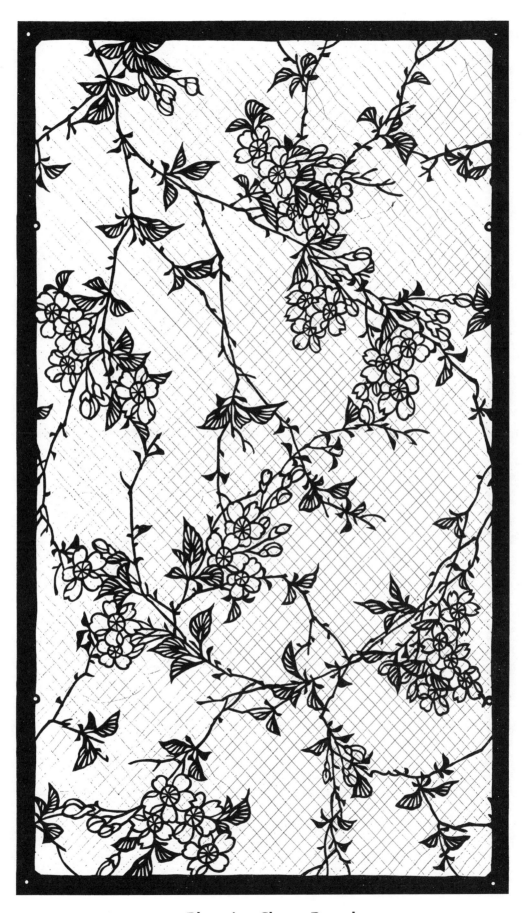

69. Blooming Cherry Branches

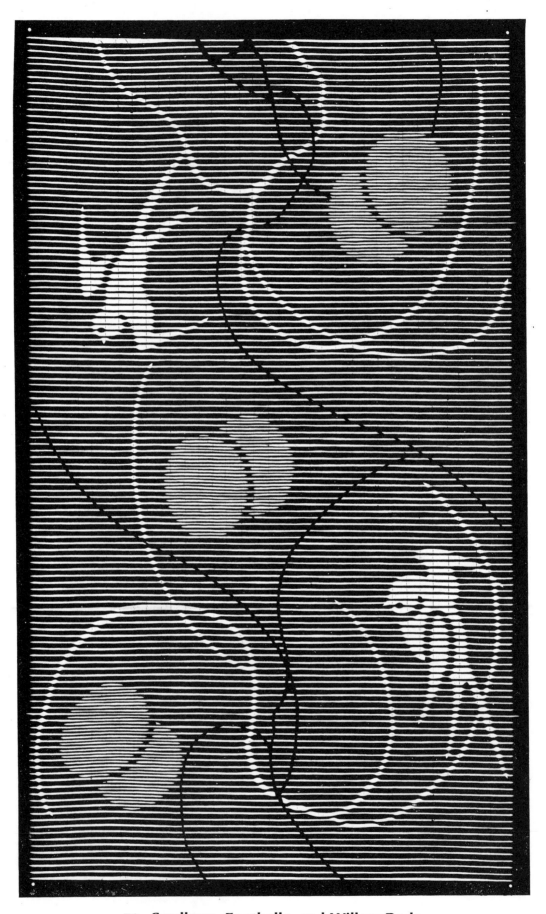

70. Swallows, Footballs, and Willow Rods

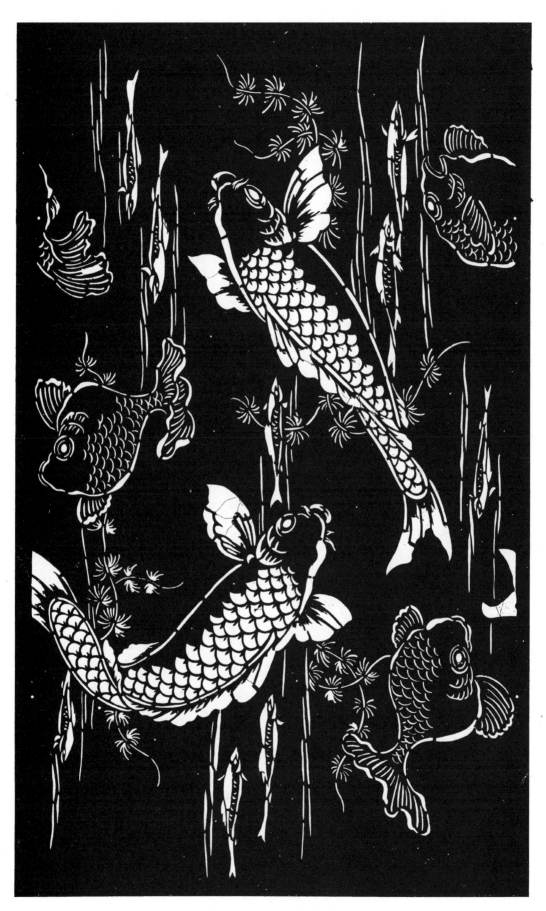

71. Swimming Carp, Goldfish, and Trout

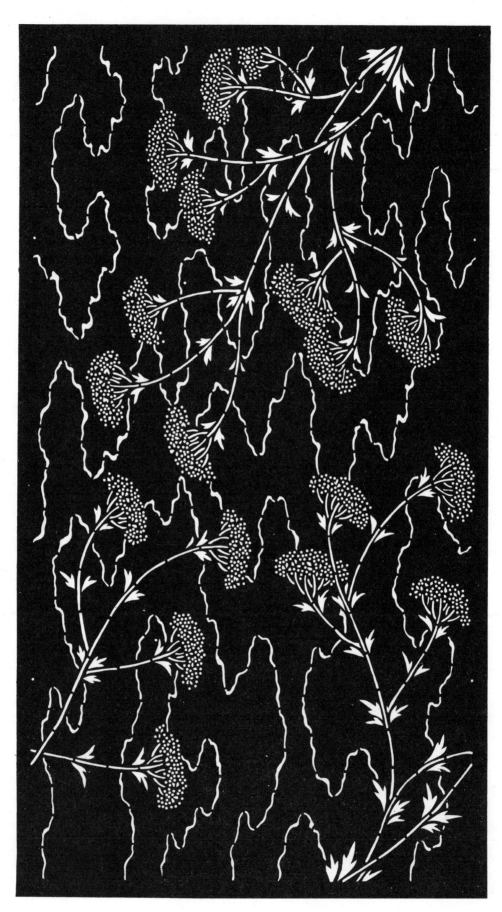

72. Ominaeshi (An Autumn Plant)

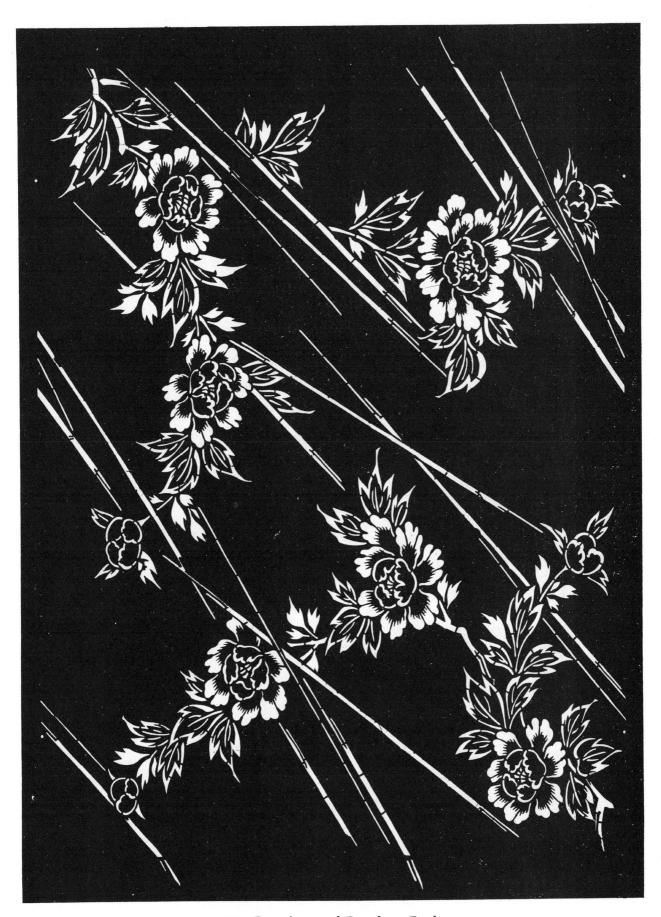

73. Peonies and Bamboo Rods

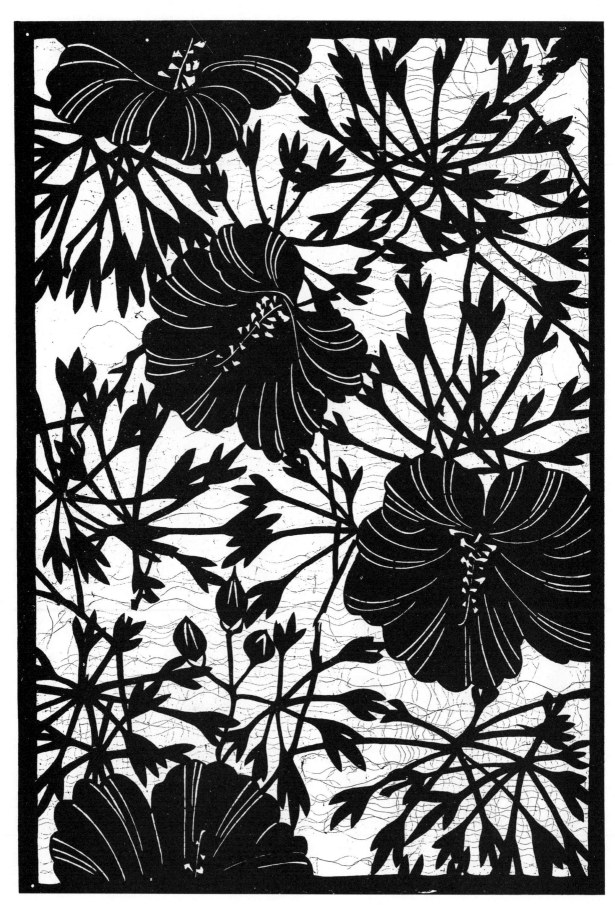

74. Blooming Hibiscus

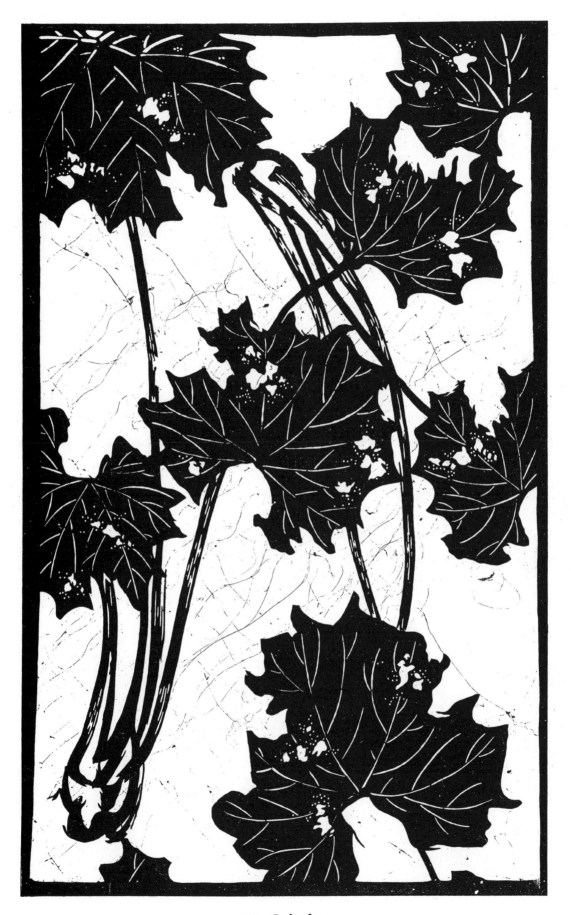

75. Coltsfoot

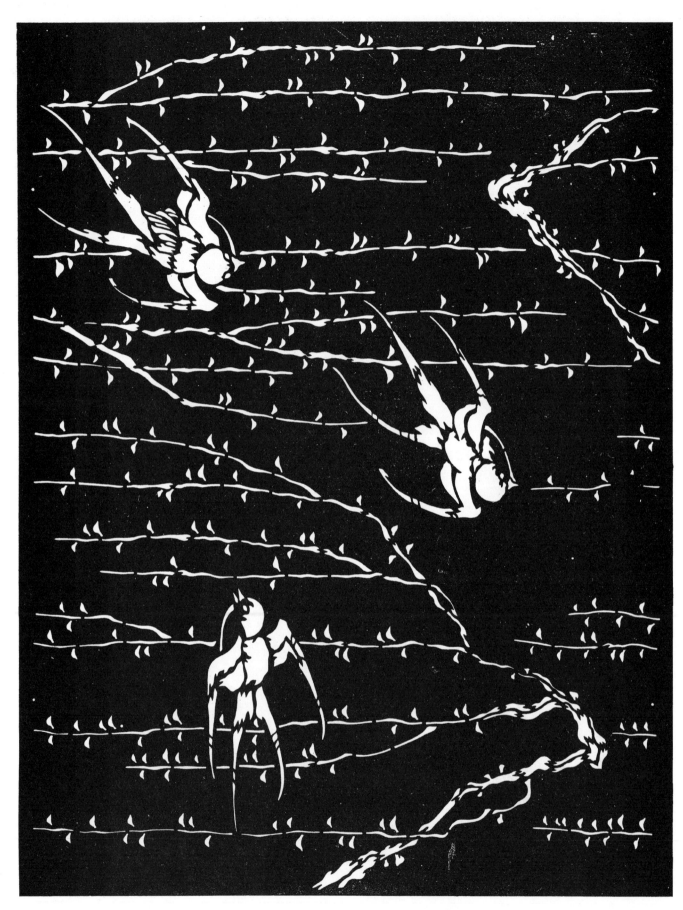

76. Weeping Willow and Swallows

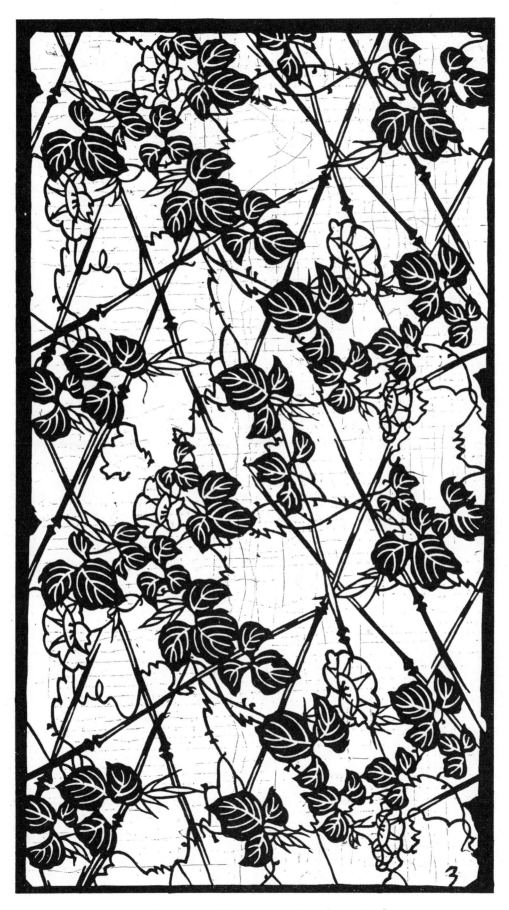

77. Morning Glories on Bamboo Rods

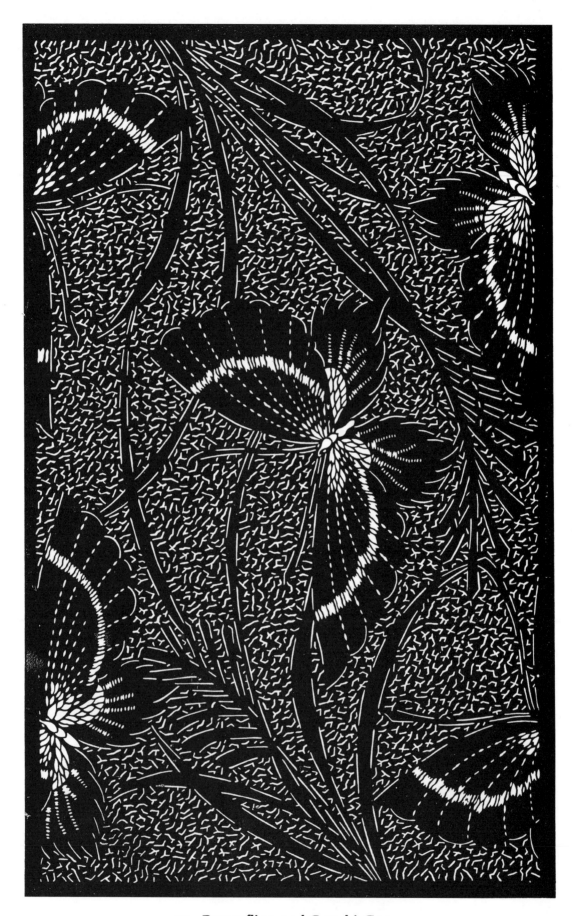

78. Butterflies and Susuki Grass

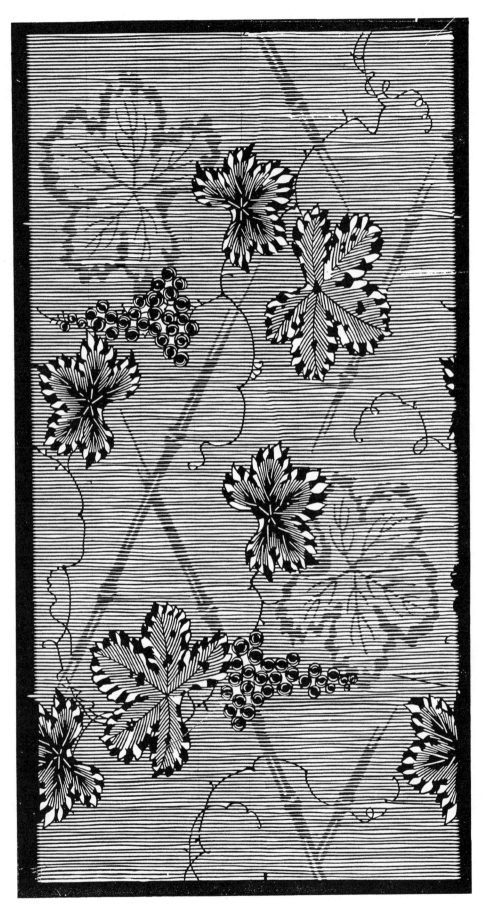

79. Vine Tendrils and Bamboo Rods

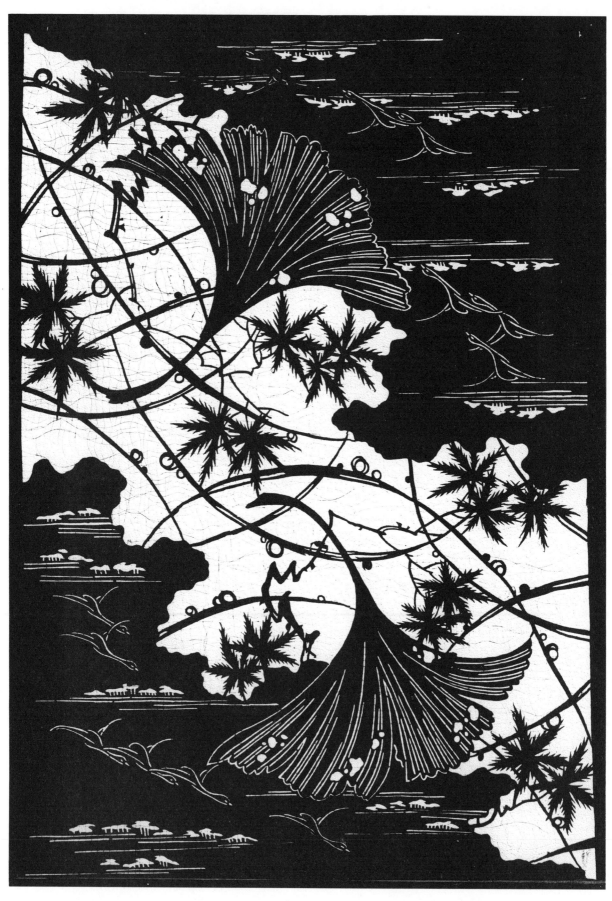

80. Fall Motif: Ginkgo Leaves, Maple Branches, Blades of Grass (With Dew) and Wild Geese over an Island with Pine Trees and Fields

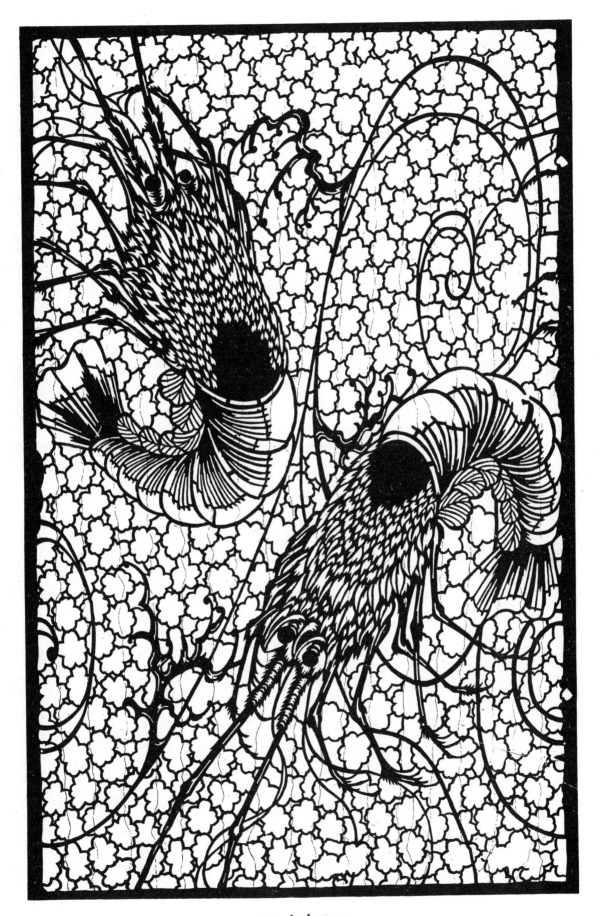

81. Lobsters

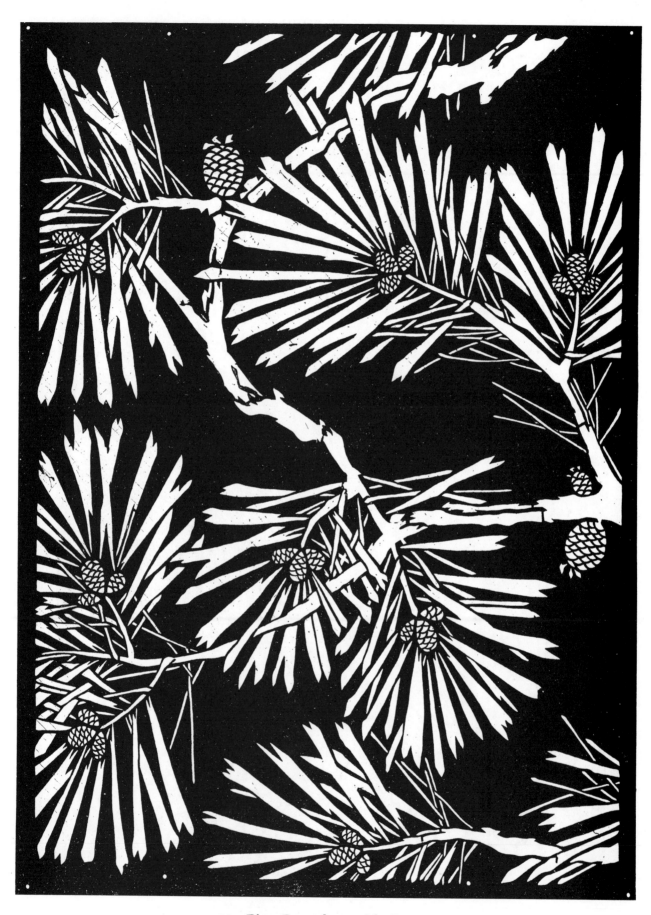

82. Pine Branches with Cones

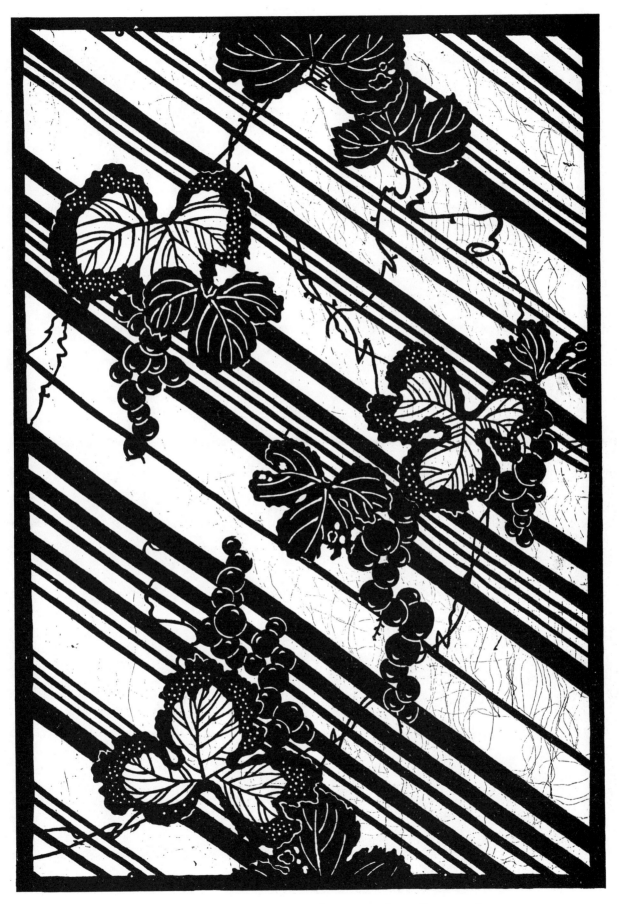

83. Vines on a Diagonally Striped Background

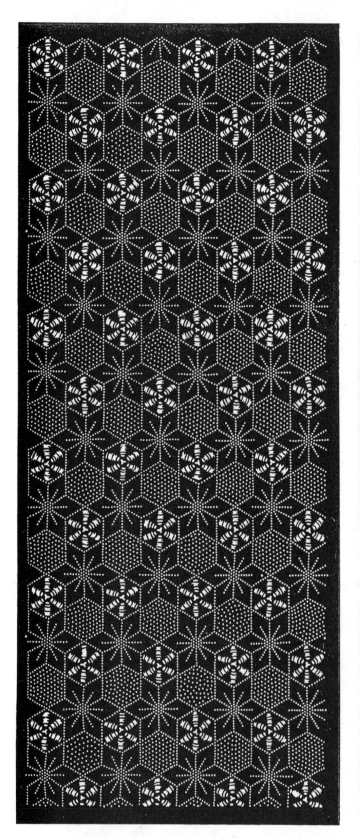

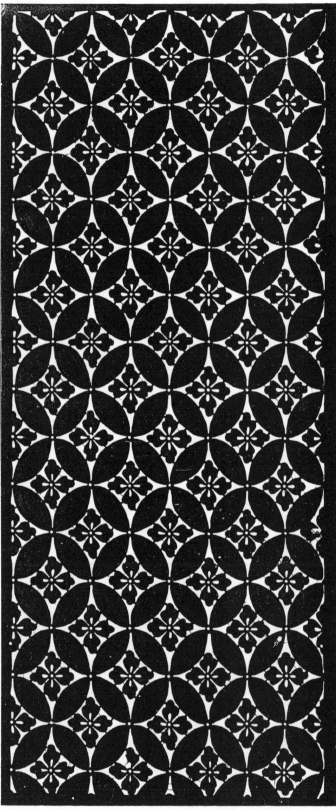

**84. Star Pattern with
Snow Flowers**

**85. "Shippo" Pattern (Overlapping
Circles) with Hishi Flowers**

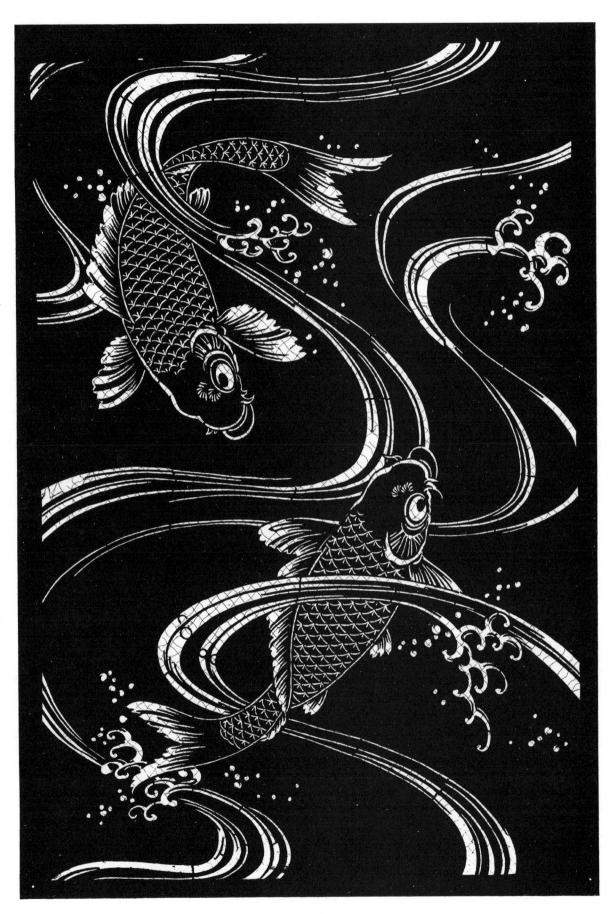

86. Swimming Carp

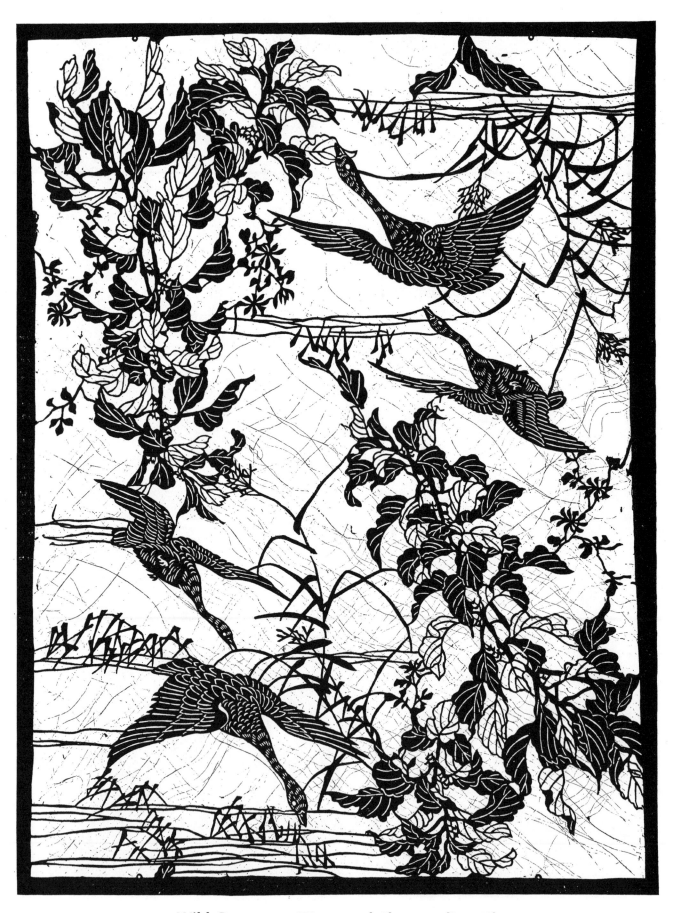

87. Wild Geese over Water and Chenopodium Plants

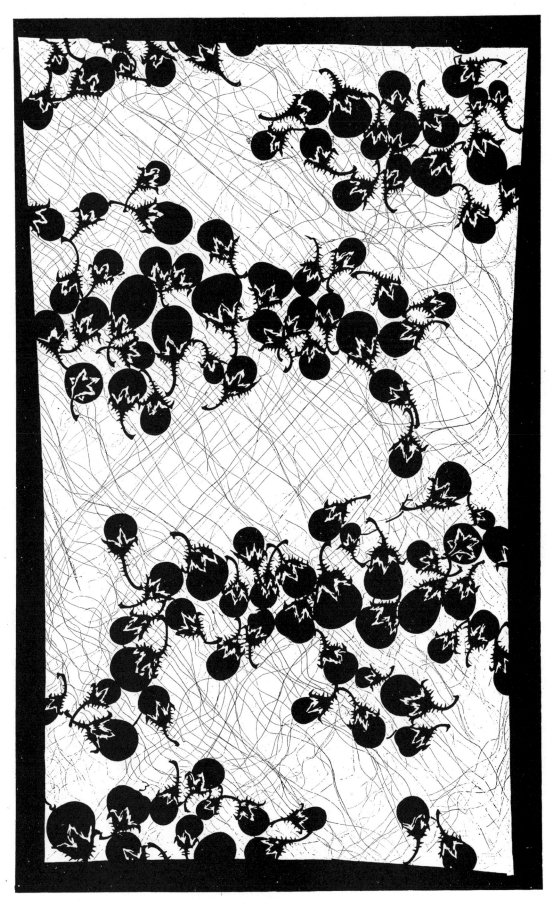

88. Eggplant (*Solanum melongena*)

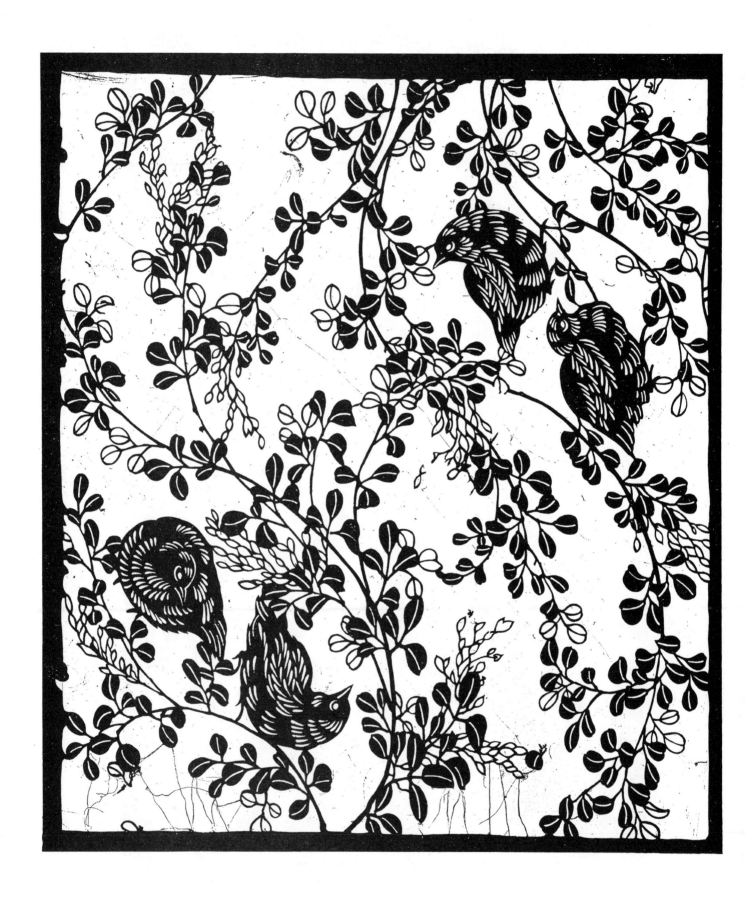

89. **Quail in Hagi Bushes**

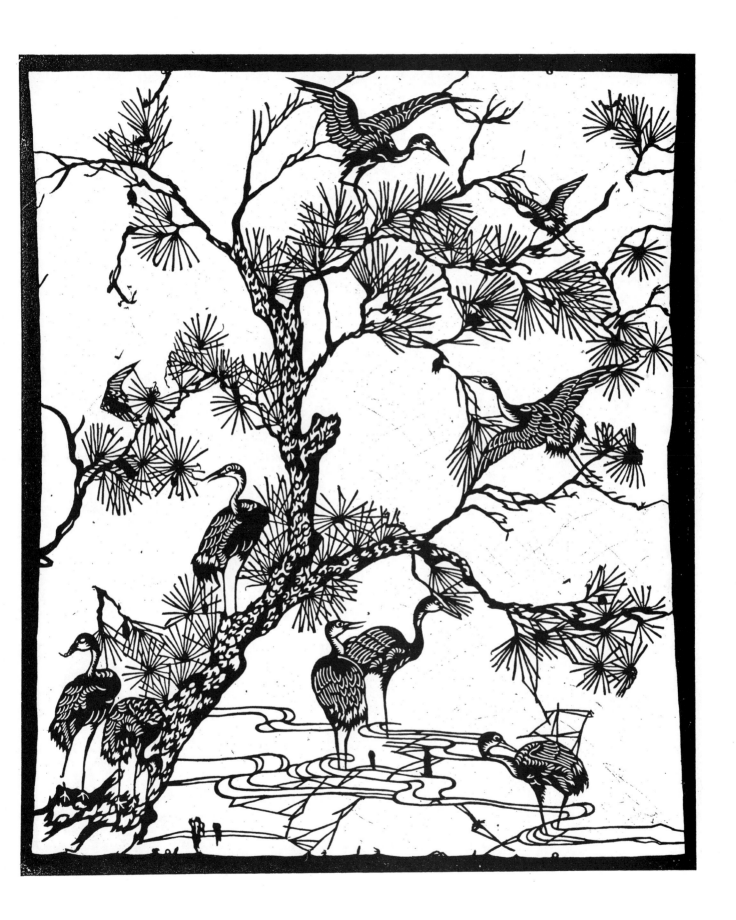

90. Cranes in Water and in a Pine Tree by the Shore

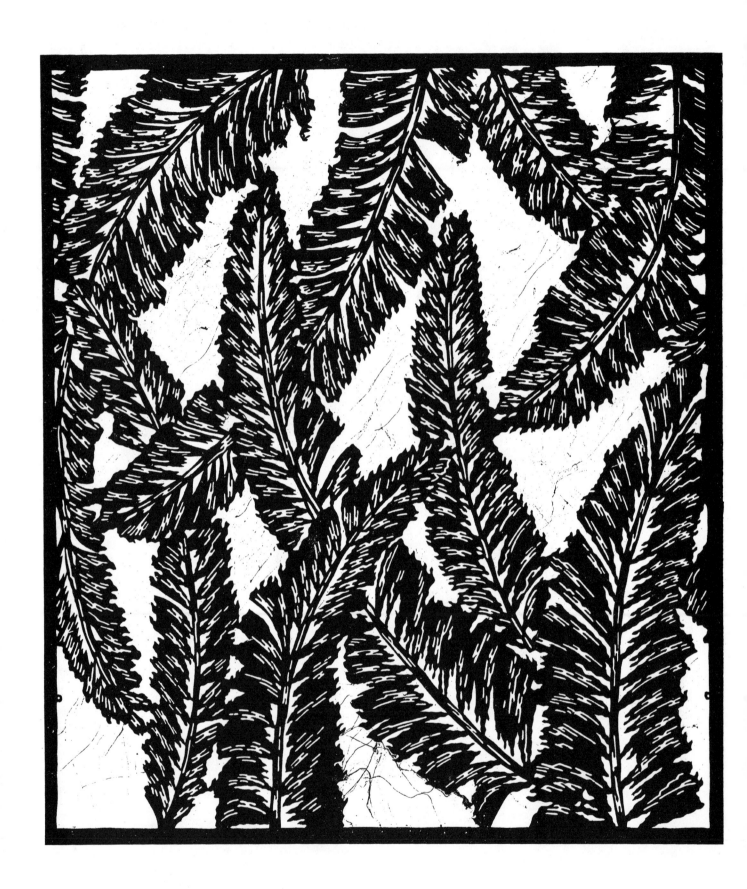

91. Torn Banana Leaves

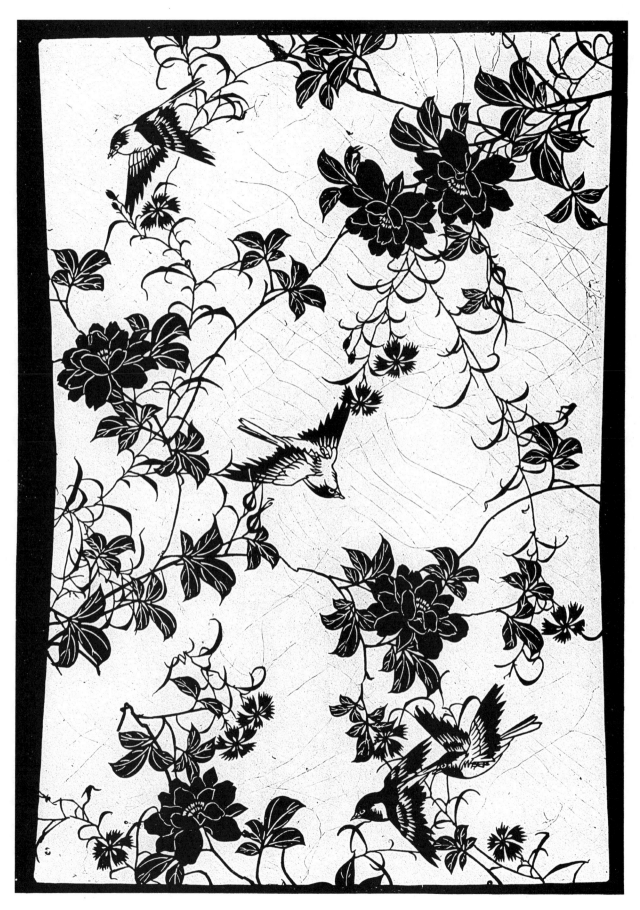

92. Roses, Carnations, Sparrows

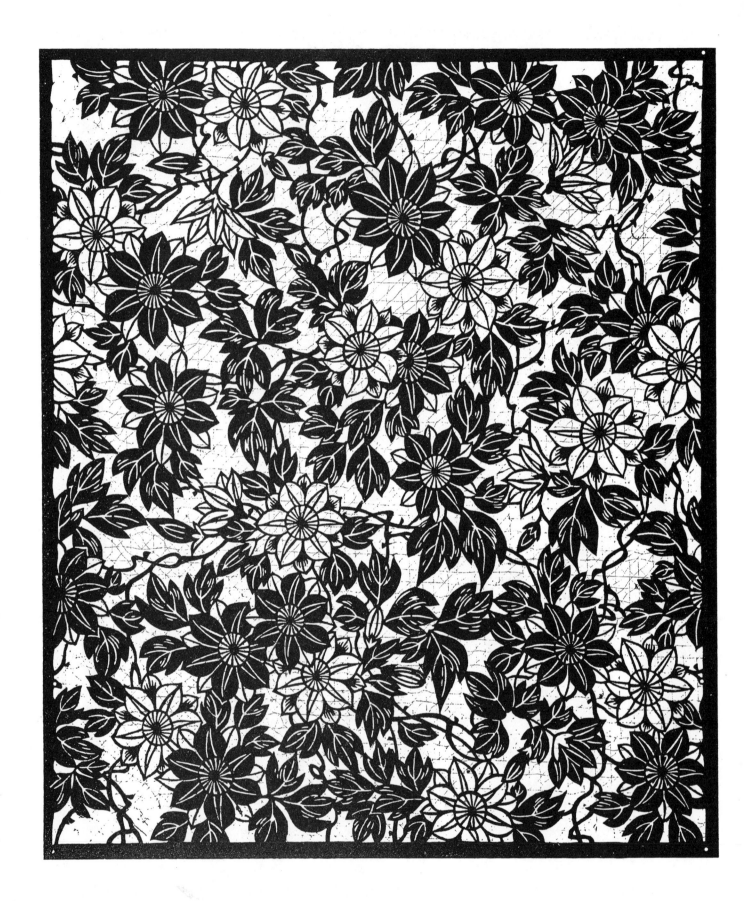

93. Clematis

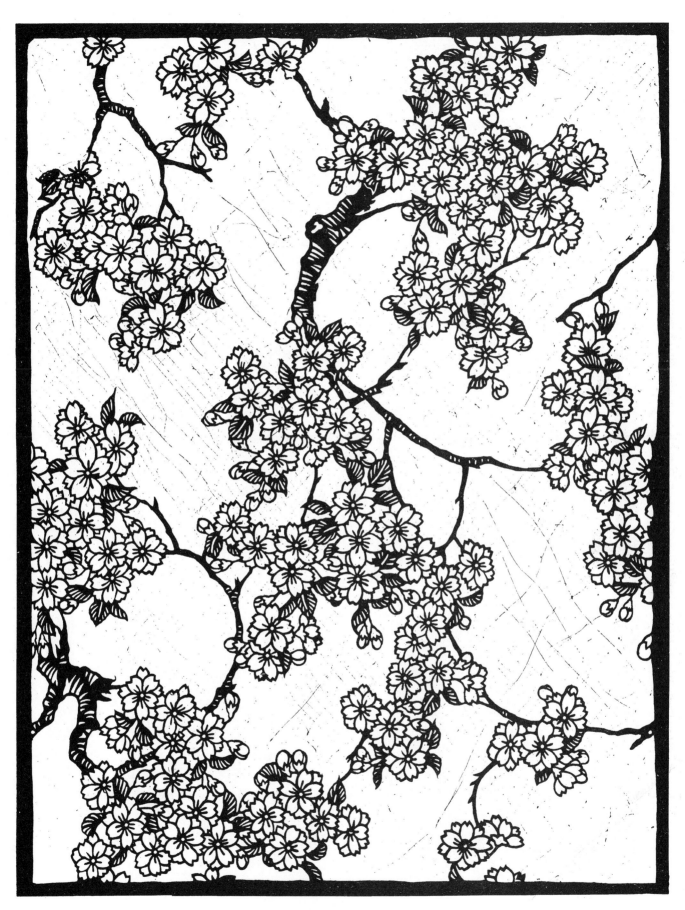

94. Blooming Cherry Flowers

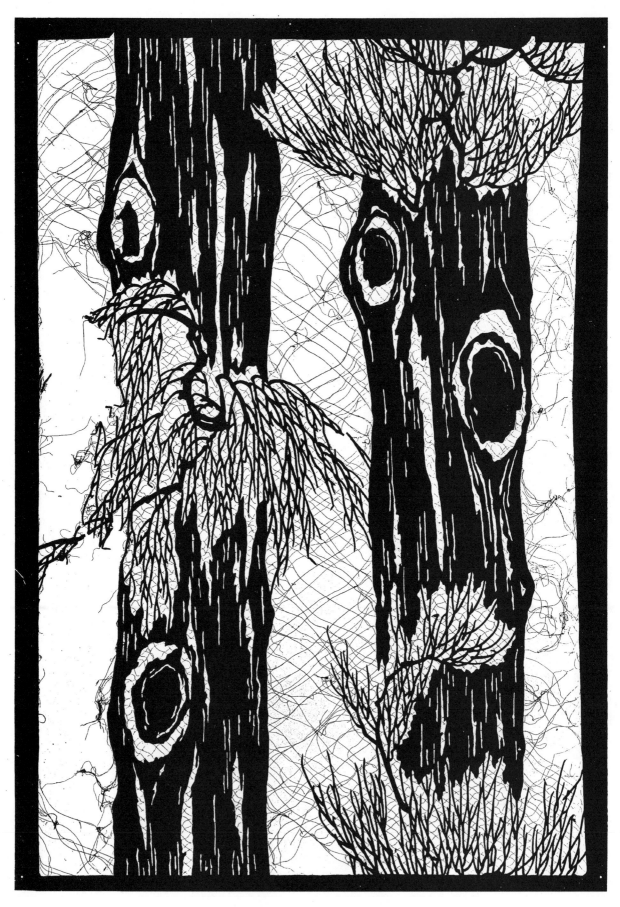

95. Dying Cedar Trees

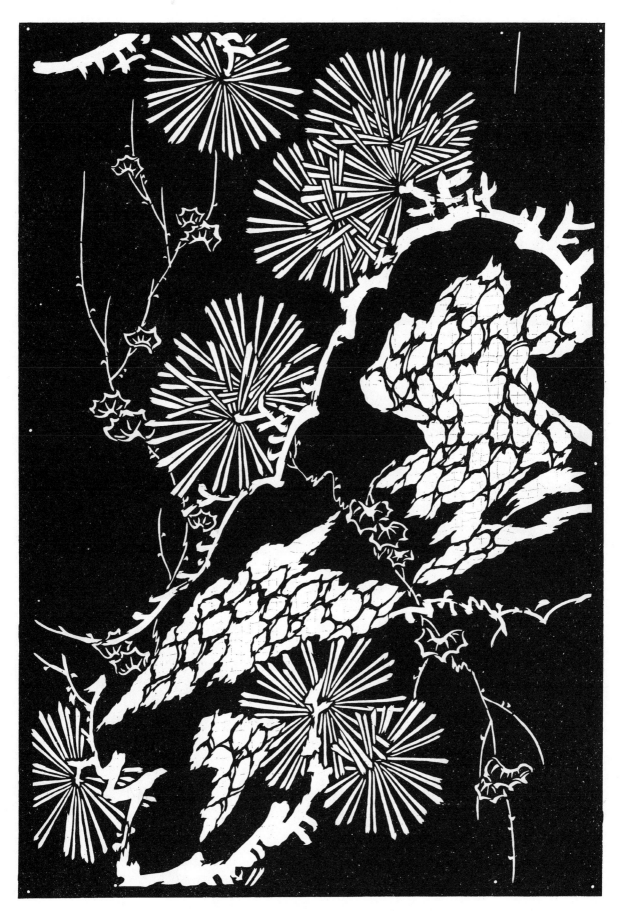

96. **Pine and Climbing Plants ("Tsuta")**

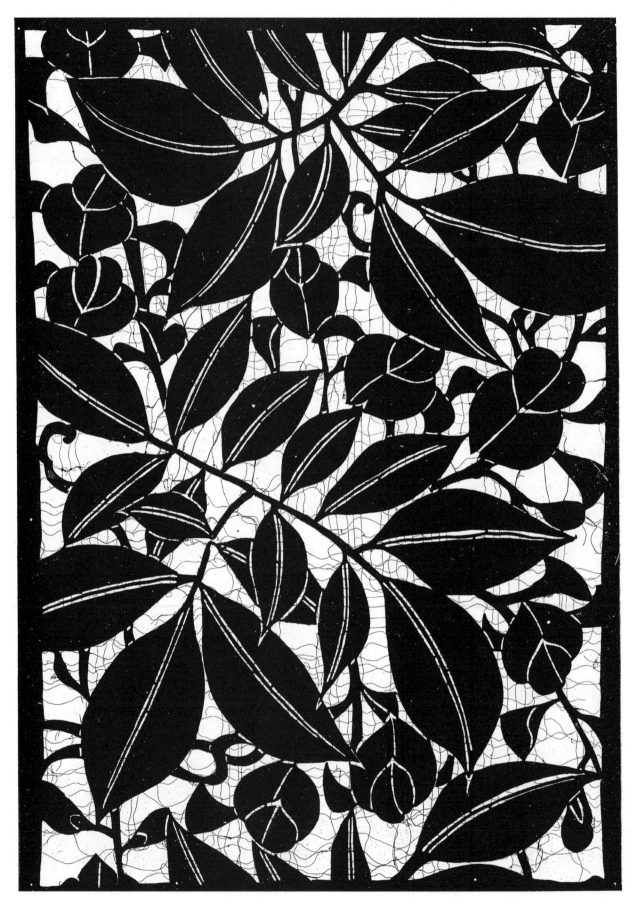

97. Glycine Leaves

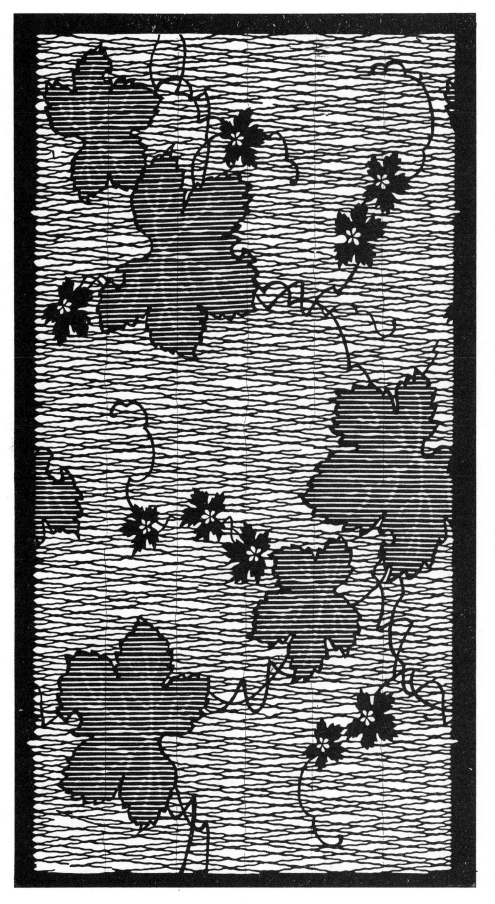

98. Vines

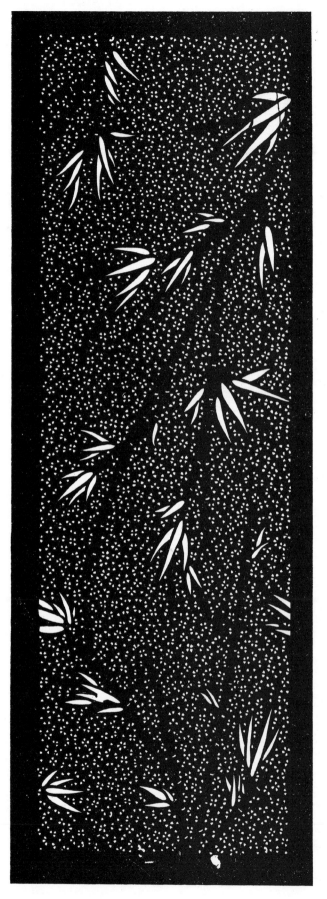

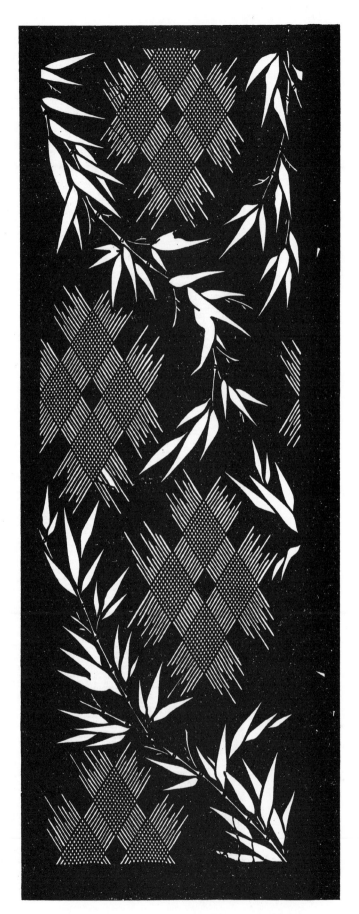

99. Peach Branches and Cherry Blooms　　　**100. Bamboo with Braided Patterns**

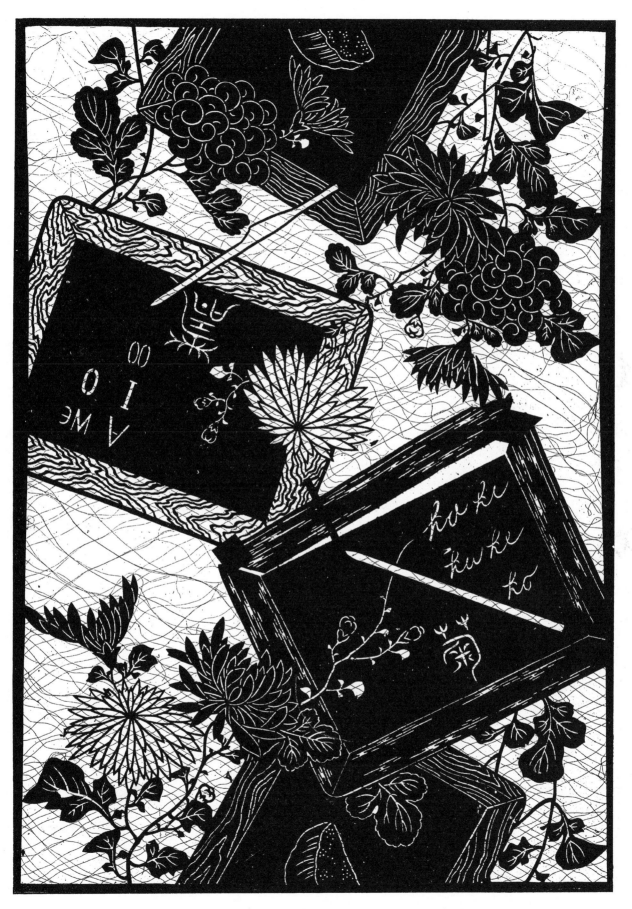

101. Written on Slates with Pencils and Chrysanthemum